Then&Now

PALATINE, ILLINOIS

The inscription in the lower left ribbon reads "113th Illinois." Company E of this volunteer infantry regiment was formed by Palatine area men with Mason Sutherland as captain. The regiment left Camp Hancock, near Camp Douglas, Illinois, on November 6, 1862 for Tennessee. Though Mason Sutherland died of disease before he saw action, many Palatine men did return from the Civil War and they continued to hold reunions for many years.

Then & Now

PALATINE, ILLINOIS

The Palatine Historical Society

ARCADIA

Published by Arcadia Publishing,
an imprint of Tempus Publishing, Inc.
3047 N. Lincoln Ave., Suite 410
Chicago, IL 60657

Printed in Great Britain.

Library of Congress Catalog Card Number: 2002107398

For all general information contact Arcadia Publishing at:
Telephone 843-853-2070
Fax 843-853-0044
E-Mail sales@arcadiapublishing.com

For customer service and orders:
Toll-Free 1-888-313-2665

Visit us on the internet at http://www.arcadiapublishing.com

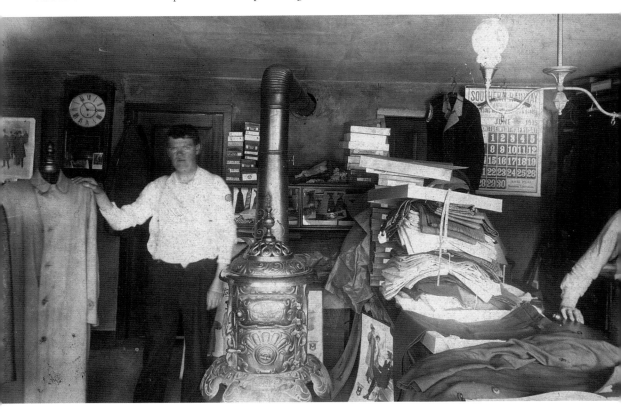

Chase (Charles) and Ernest Prellberg Sr. are working inside their tailor shop at 17 West Railroad. The elder Prellberg opened the store in about 1868. It was a family affair. There were quarters in the back of the building where the family lived. Ernest had five children with his first wife Johanna and ten children with his second wife Sophie.

CONTENTS

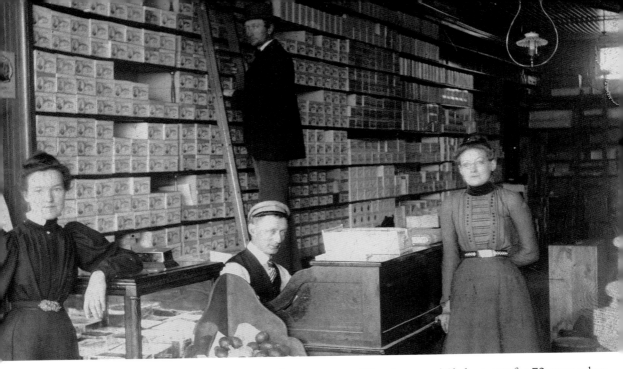

Harry Schoppe had operated a store at the southwest corner of Brockway and Slade streets for 72 years when he died in 1966. He was in partnership with his brother Louis until Louis' death in 1944. This photo from inside the shop probably dates back to the turn of the century. From left to right are: Amanda (Mrs. Louis), Harry, Amalia (Mrs. Harry), and Louis on the ladder.

ACKNOWLEDGMENTS

Writing this book would not have been possible without the assistance of Marilyn Pedersen, Clayson House Museum Coordinator. Volunteer Nancy Cairns edited the manuscript for clarity, grammar, and punctuation. Marilyn Pedersen and volunteer Frank Regan checked the copy for accuracy. The "Tuesday Toilers" patiently listened to my enthusiasm and frequently made helpful suggestions.

I thank the authors of these publications of the Palatine Historical Society for the research they had already done, which lightened my load: *Hillside Cemetery* by Connie Rawa; *Palatine 1929* by Joan Murray; *A Slice of Life, Palatine 1901* by Dave Hammer; and *Palatine 1866-1991, 125 Years, Centennial Book Edition Updated*. Florence Parkhurst, a lifelong resident of Palatine, left us four thick notebooks of Palatine family genealogies.

The Palatine Historical Society has an extensive and varied collection of historical materials. I am indebted to the Palatine residents and their heirs who have gifted these materials to the Society, and to the volunteers who have pursued them, preserved them, and catalogued them.

Alice Rosenberg, Archivist
Palatine Historical Society
Clayson House Museum

INTRODUCTION

Several years ago I had the pleasure of producing the book *Images of America: Palatine, Illinois*. To my surprise, this current project turned out to be more interesting, more challenging, and much more time-consuming. In the summer of 2000, Arcadia Publishing notified us of the *Then and Now* series. I went through our photograph file, making notes to see whether we had enough old-time pictures of sites not previously used or, in a few cases, different views of some familiar images. There seemed to be plenty to work with.

Next I copied all the photos, arranged them by area and drove around inspecting the buildings. Marilyn Pedersen made some of the trips with me. That autumn I took two rolls of film. I am not a professional photographer, and I learned two important things with that experiment. Shoot to the west in the morning and to the east in the afternoon, or, if you are able, pick an overcast day. The trees are more plentiful and fuller than they were 50 to 100 years ago, and there was no clear view of most of the buildings. I had to wait for the leaves to fall! It was the end of November before the trees were bare. If anyone remembers the month of December 2000 in the Chicago area, it snowed and froze and snowed and froze. I finally took most of the pictures used in this book in March of 2001.

The next step after completing my photography was to begin the process of researching each set of photographs, the old and the new. The Historical Society has an archival collection that consists of many types of materials that are easily accessed. There are also census records, family genealogies, an obituary file, and high school yearbooks. Our telephone books date back to 1910 and were especially helpful in tracking down later occupants of the buildings. Unfortunately, there are some missing years in the set. Usually in a day, I was doing well to research four sets of photos. As I continued researching at Clayson House, I began writing the copy at home.

Another reason the process took so long is that I am a volunteer at the Historical Society. I work at the Clayson House Museum in the Florence Parkhurst Library every Tuesday, when I am in town. From the summer of 2000, when I began the project, until May 2002, when I mailed the manuscript and photographs to Arcadia, I was out of town a great deal.

After the Indian Wars in this area of Illinois ended with treaties, settlers from New England and New York came here as early as 1835 to establish farms. The government survey of public lands in "Township 42 North of the Base Line in Range 10 East of the 3rd Principal Meridian," later to be named Palatine Township by these and other settlers, was published in 1840 and land sales began in that year. After the railroad survey was published in 1853, Joel Wood, who owned 80 acres south of what would become Palatine Road/Chicago Avenue, purchased two 80 acre parcels north of that line. Elisha Pratt purchased 80 acres south of that line. Both men platted small subdivisions to serve the surrounding rural countryside, including interior streets and house and business lots for trades-people and mechanics needing the railroad. Local residents voted to incorporate the Village of Palatine in 1866, and the state legislature endorsed this incorporation in 1869.

Growth continued slowly in the village. A few small subdivisions increased the size and population. There were probably a few citizens who commuted to Chicago to work, but most of the residents were local business people, teachers, railroad workers, professionals, or farmers who lived in town. In 1940, there were 4,434

residents in Palatine Township. Half of them lived within the village limits. The big explosion in population began after World War II, in the 1950s. Palatine became a suburb. Most of the people who lived here worked elsewhere, usually in Chicago. As business and industry moved from Chicago to the suburbs, more jobs opened up closer to town. In the past 20 years or so, many new homeowners have moved out to the northwest suburbs, Palatine included, to be closer to their work places.

When I drove around Palatine in March 2002 taking my last roll of film, I was astonished at the amount of housing that had been and is being built. There are some houses, but most of the growth has been in condominiums and attached town houses. Every empty space is being filled in. Unfortunately, to my way of thinking, some of the growth has been at the expense of old houses which have been razed to be replaced by multiple housing.

There is some industry within the Village of Palatine, but none on a large scale. More manufacturing is located in Palatine Township. Palatine's downtown is still a small area. Several shopping plazas have been built, but there are no large malls such as Woodfield and Randhurst, which are located in nearby towns. The village is not an entertainment center. It has its share of restaurants and saloons, but no professional theater and no movie house.

Palatine has retained a great deal of the character of its early days. It is a village of homes. Its retail establishments are here to serve its residents, who are now wage earners, business owners, and professionals instead of farmers. Palatine is a town that cares about schools and libraries and parks. It is neat and clean and as safe as any community can be in these modern times. It is a good place to live and raise children.

Alice Rosenberg

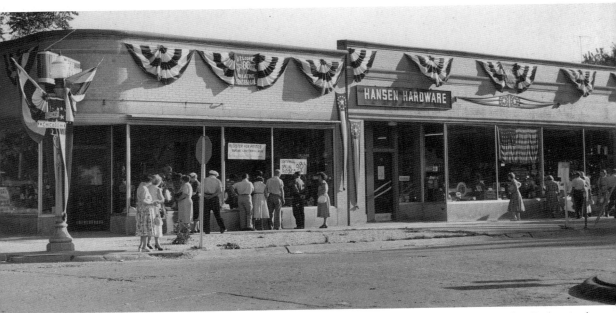

The Village of Palatine celebrated its centennial in July 1955. These citizens are interested in the displays in the window of Nelson's Flower and Gift Shop, which had been established on the southwest corner of Palatine and Brockway Streets in 1952. Next door, Hansen Hardware had just moved into the facility that was vacated by National Tea grocery. After a fire in the flower shop in 1971, Hansen remodeled that area to enlarge his facility. The Hardware Store remained there until the 1990s. Kramer Photographers now occupies the building.

The room in this photo, which was probably taken in the late 19th century, is located in the center of downtown Palatine. It was not uncommon for a businessman and his family to live behind or over the store. This lovely Victorian parlor was in the second floor apartment over Zimmer Hardware. A.C. Zimmer and his wife Sophie are seated together. The other woman is not identified. The apartment is now occupied by a tenant of present owner Nancy Martino.

Chapter 1
DOWNTOWN

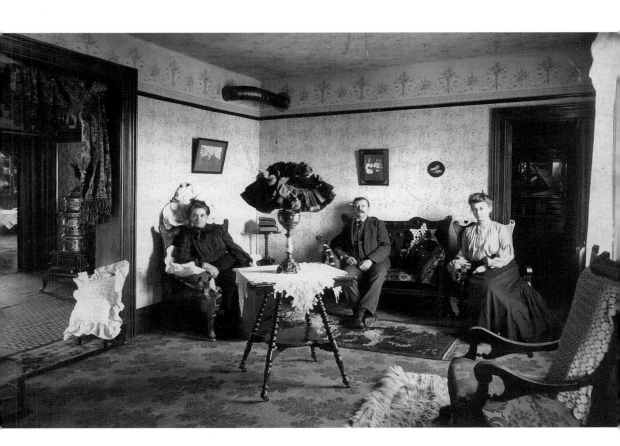

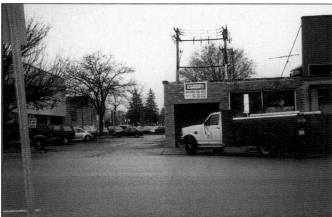

Traveling north on Brockway Street from Palatine Road (Chicago Avenue), the Bruhns Meat Market was on the west side at No. 10. Henry Bruhns came to America in 1893 at the age of 17 and worked several years as a cattle dealer in Schaumburg before moving to Palatine in 1901. He operated his meat market for 18 years before selling it because of ill health. In 1929, the building housed the Perry Barber Shop. James D. Perry and his wife Rosella also lived at this address. The building was razed and replaced with a driveway and parking area for the Palatine Savings and Loan, when it was built on the corner facing Palatine Road in 1956. First Nationwide Bank took over the corner facility in about 1990 and later moved out. The building now houses offices.

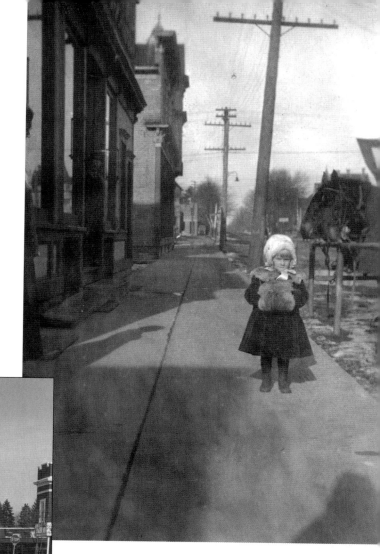

Zimmer Hardware at No. 18 North Brockway was founded by Albert C. Zimmer in 1883 at the corner of Slade and Bothwell. It was later moved to this address and the family lived in an apartment upstairs.

Zimmer was born in Wheeling, Illinois in 1856 and apprenticed as a tinsmith. After his death in 1947, the store was operated by his stepdaughter, Lydia Wienecke, and her nephew, Howard Freeman, until Lydia's death in 1958. The Freemans continued to live above the store and ran the family business until it was sold to Mike Lemonidis and Dick Brumm in 1972. The fourth and present owner, Nancy Martino, purchased the hardware store in 1996. The facility has been remodeled over the years, but it still retains some of its old-time features, such as a wooden elevator and squeaky

hardwood floors. Judging from the appearance of the Schoppe Building to the north and the horse rail and the dirt streets, this photo appears to have been taken near the end of the 19th century. In October 2000, Zimmer Hardware was honored as one of the "Retailers of the 20th Century" by the Illinois Retail Merchants Association. Ms. Martino plans to continue operating the store, which is the oldest business institution in Palatine.

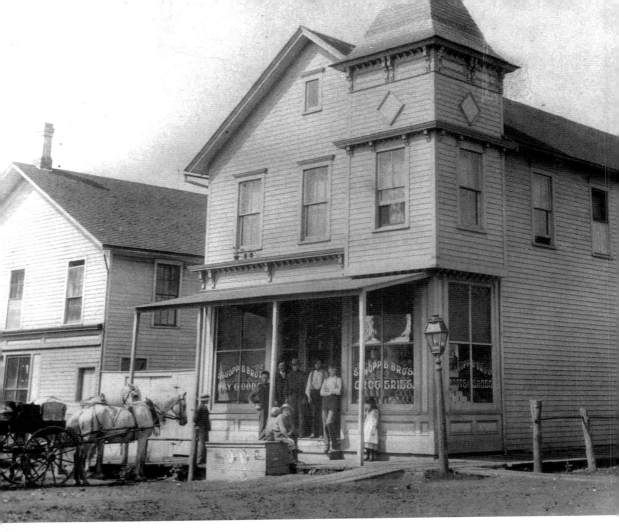

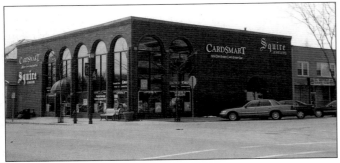

Louis Schoppe opened his store in 1892 and was joined a year later by his brother Harry. The Schoppes had enlarged their original building in 1901 by erecting a two-story addition and basement on the land they owned next door on Brockway. At the same time, they installed a gas plant to operate 33 jets in the store to light it "as bright at night as it is during the day time." Schoppe Brothers continued on the southwest corner of Slade and Brockway Streets until a year after Harry's death in 1966. For a short time after 1967, the building was occupied by a ceramic shop, and in the fall of 1969, 26 North Mod Shop opened on the premises, but not for long. The building was destroyed by fire on 16 November 1970. It was replaced by this modern building which is currently occupied by Squire Jewelers, Crystal's Hallmark, and County Club Golf Outlet.

This 1915 photo shows the Kunze saloon building being remodeled into Dr. C.A. Starck's Palatine Hospital.

The facility opened in 1916 on the second floor with 10 beds, an operating room, a laboratory, a nurse's station, a single-line telephone, Dr. Starck's office, and a dentist's office. Dr. Starck also operated a nursing school. There were seven girls in the June 1946 graduating class and five more in training, but the school closed in 1950. When the building was completed in 1916, the first floor housed the State Bank of Palatine (which moved into its own building at Slade and Brockway in 1931), the Chicago Telephone Co. exchange, and the post office. In 1946, Palatine Drug occupied the corner store and later it housed Coleman Drug and the U.S. Army Recruiting Office. The "Matter of Time" shop shown in this photo has moved out since this photo was taken. Offices are located upstairs and a store and barber shop face Brockway.

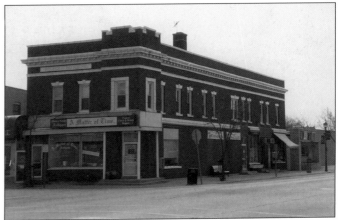

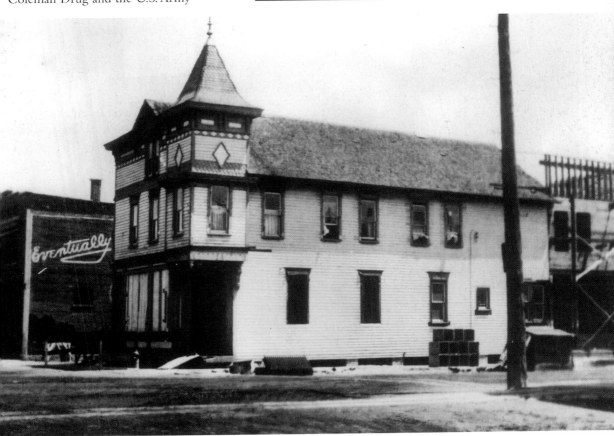

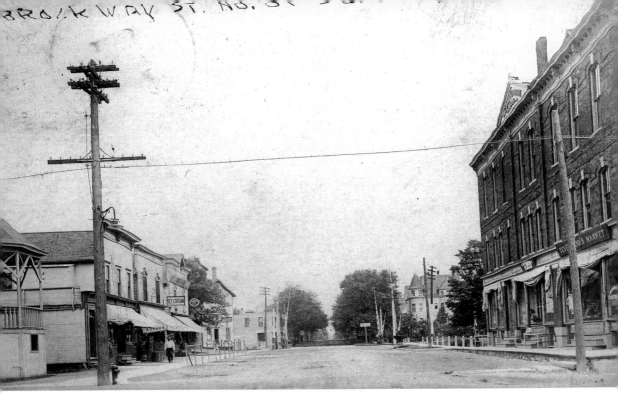

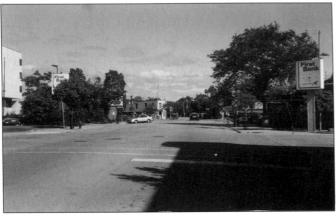

L ooking north on Brockway from Slade Street in the early 1900s, one could see the bandstand and three store buildings on the west. The Batterman building was on the east. Flury Bakery, which originally faced Brockway, was moved around the corner to Slade Street and the bandstand was built on that spot. An article in the *Palatine Enterprise* newspaper mentions the bandstand as early as 1910. The First National Bank, which had been established in temporary quarters in 1921, erected a building on the bandstand site in 1925. The bank closed its doors permanently in 1932. The three businesses on the west side changed hands many times. In 1925, one of the wooden buildings was remodeled in order to house a National Tea Store. The grocery had begun doing business on the ground floor of the old village hall on Slade Street until its new facility was ready. Three businesses remained there until a fire destroyed one of them, the Ben Franklin Store, in 1973. The Palatine National Bank took over the area.

W.R. Comfort Sons had occupied this location on the west side of Brockway, next to the tracks, since 1874.

Wesley Comfort came into the lumber and grain firm when, at age 17, he married the daughter of Joseph Slade, the originator of the business. This unusual bungalow-type office was built by his two sons to replace the old grain elevator/office. A formal opening for the building was held on the 24th and 25th of August, 1929. The building was demolished in November of 1967 to be replaced the next year by the new Palatine National Bank Building shown here. There had been no bank in Palatine since 1932 until the Palatine National Bank was organized in December of 1944 and occupied a building on the northwest corner which had been the defunct First National Bank. In 1988, Palatine National Bank became the Suburban National Bank and is now Harris Bank.

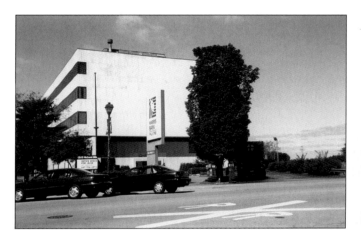

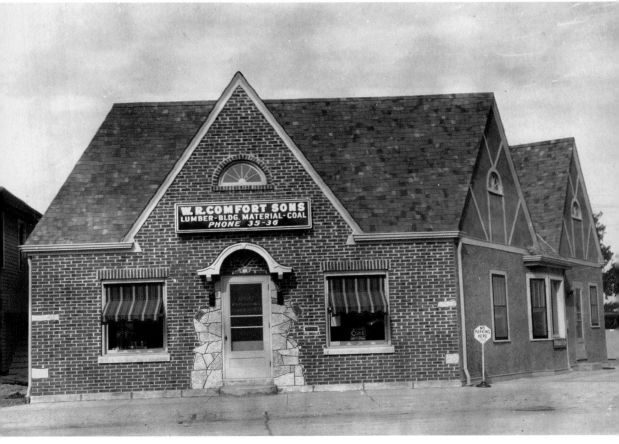

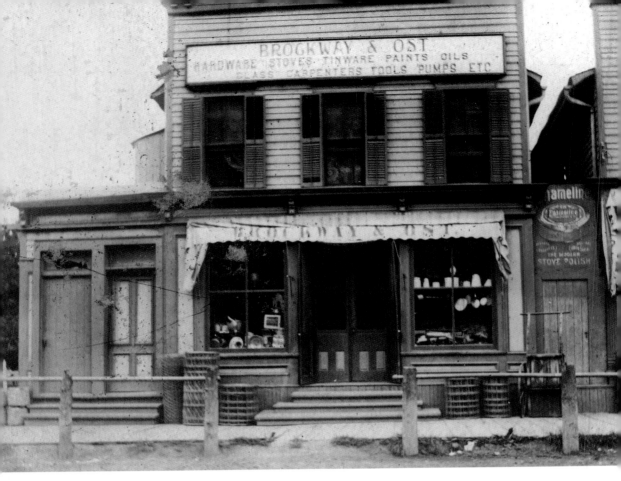

B rockway Hardware was one of the original three buildings on the Harris Bank property. William Brockway had worked for the Northwestern Railroad. Because of poor health, he went into partnership with William Ost in 1901, buying this hardware store which had been owned by H.W. Meyer. Shortly thereafter he became sole owner and operated the store until 1911, when he sold it to his employee Henry Bockelman. Brockway then returned to the railroads.

Bockelman purchased the three-building business block and in 1925 he and his son William (who had been made his partner) moved the hardware store two doors north and the building in this photo became National Tea Co. Henry Bockelman died in 1943 and the store was sold to Gunnar Hansen in 1948. Although Hansen True Value later moved its main operation to the southwest corner of Brockway and Palatine, an annex of the hardware store remained on Broadway until the 1973 fire, when the property became a parking lot for the Palatine Bank.

The Batterman Brick Block was built on Brockway in 1884 by Henry C. Batterman on the piece of land known as "the triangle," which was created by the railroad tracks on the north crossing Slade Street on the south. Two small buildings behind it on Slade Street had a variety of occupants. This tallest building in Palatine contained stores on the street level, offices above and the Opera Hall on the third floor. Batterman died in 1902 and the building was demolished in 1938. The lot then remained empty for 24 years. During World War II, a large board titled the "Palatine Roll of Honor" stood here. It contained names of all the Palatine residents serving in the armed services. At one time, residents turned down a referendum by two to one for the village to buy the 6,900 square-foot parcel for a park. The William H. Heise interests purchased the property and erected this present structure, the First State Bank and Trust Company of Illinois, which opened in December of 1962.

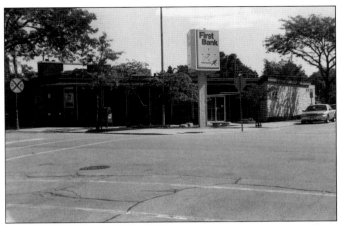

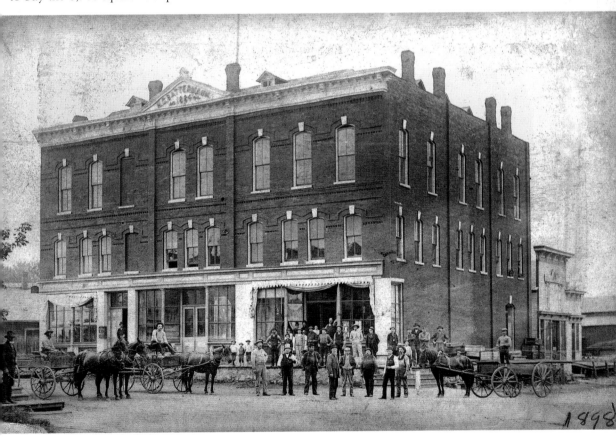

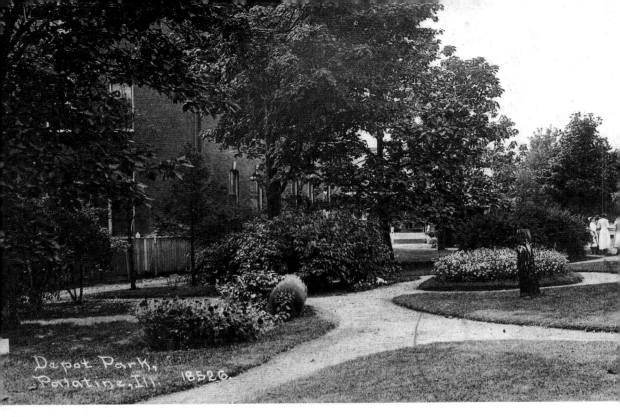

Depot Park, Palatine, Ill. 18526

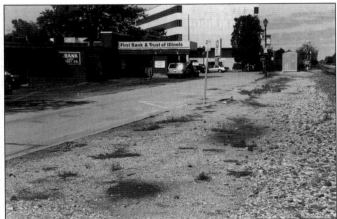

This picture of Depot Park from the turn of the 20th Century looks to the west from just west of Bothwell and south of the railroad tracks. The park was located on the north side of the Batterman Building (seen on the left). The park probably disappeared when the Chicago and Northwestern Railroad built a third rail on the south side of the tracks in 1930. The present street on the north side of the First Bank & Trust Company drive-through was probably created at that time as a dirt road. In 1948, when the first depot was removed, Railroad Drive was paved from Plum Grove to Brockway, which should have included this section. After many years, an effort was made to improve the looks of the area. Since this photograph was taken, a lovely walk, decorative fence, and landscaping have been installed.

This building, on the west side of Brockway just north of the tracks, has not changed in looks as much as it has in ownership since August Hackbarth opened a garage here in 1915. Hackbarth came to Palatine in 1903 to operate a blacksmith shop on Wood Street. In 1923, the family moved to Champaign, Illinois to be near their children in college. Harry Kruse then managed the garage, which was owned by William Busse & Sons Inc., until Kruse bought the facility and became a Nash car dealer in 1932. In 1940, N.J. Michael & Sons Garage was listed at this address. Elmer Rohde operated Rohde Repair Service in the facility and also sold Kaiser-Frazer automobiles until at least 1955, perhaps later. By 1966, Auto Care Center was in the building, and remained until 1977 when Marmax Glass occupied the rear portion of the building and The Frame Corner was situated in the front portion. By the late 1990's, Marmax Glass had taken over the entire building.

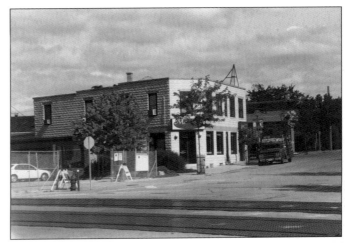

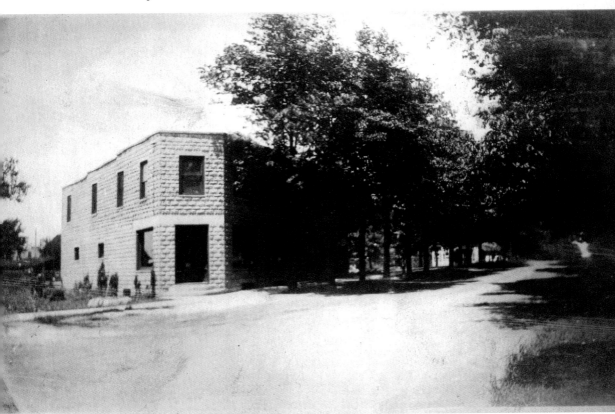

19

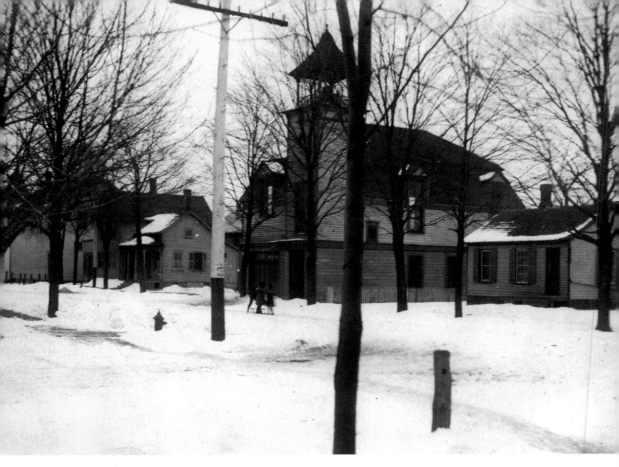

The first village hall was built in 1899 on the south side of Slade Street, east of Brockway. The fire station was downstairs and the upstairs was used for meetings and entertainment. The original bell in this photo now sits in a tower built on the side of the Clayson Carriage House Museum. The Catholic Church occupied the second floor in 1930 and placed a cross on the roof after a new village hall was erected elsewhere. The church constructed its own building on Wood Street in 1941 and the old hall was torn down. The volunteer fire department built the first section of the present building on the site with volunteer labor and $8,500 collected from fund-raising and donations. In 1953, an adjoining lot was bought from the Vehe estate and a $40,000 addition was erected. It contained an auditorium on the second floor that was available for public gatherings, dances, weddings, and family celebrations. The station was closed in 1981, and the property was sold. It now houses stores and offices.

This Flury Bakery building may be the oldest business structure in town. It is believed that John Patten built it as a store in the 1850s. John and Barbara Flury were survivors of the Chicago fire when they came to Palatine and bought this property in 1879. After her husband's death in 1888, Mrs. Flury continued operating the bakery and living upstairs until she closed the business on July 8, 1901 and moved back to Chicago. Her daughter, Amanda, had recently married Harry Schoppe who owned the store across the street. The bakery originally faced Brockway, but was moved around the corner onto Slade Street where it still sits. The vacant site was replaced with the bandstand, then the bank building, and is now a parking lot. Exactly who occupied the building for many years is not known, but William Roper opened a tavern here in 1932, the year that Prohibition was repealed. There were several owners before Beverly Langer bought it in 1982 and it became The Office Pub.

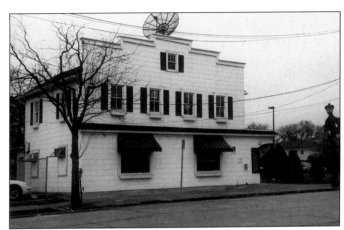

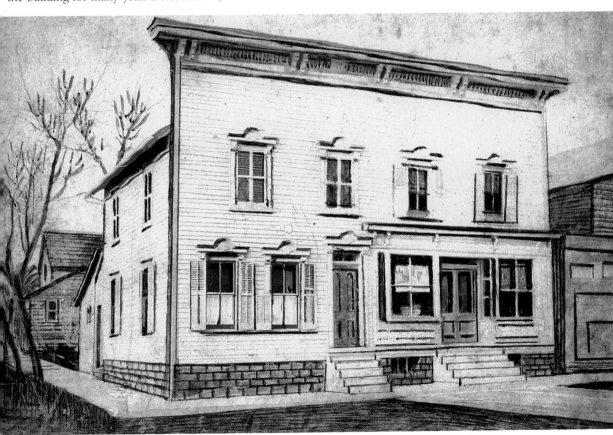

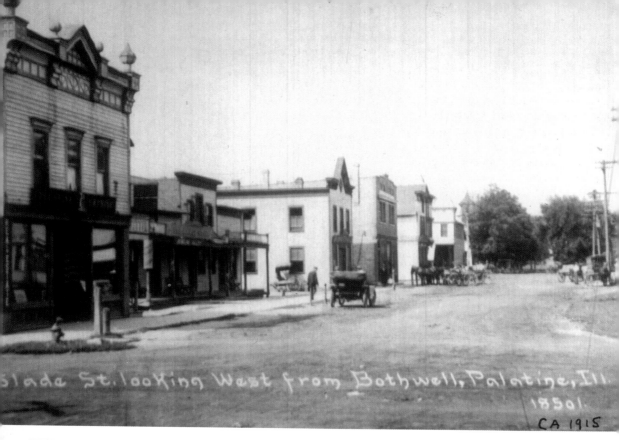

Slade St. looking West from Bothwell, Palatine, Ill. 18501.
CA 1915

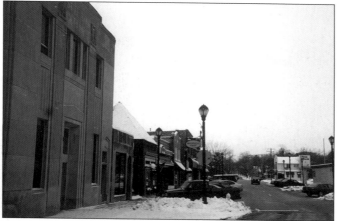

In this *c.* 1915 photo, Mosser Drug is on the corner of Slade Street looking west from Bothwell. From 1898 until 1902, the first telephone exchange was located in the back room of the building and calls were answered only during store hours. Down the block were the Annex Hotel, Schering and Lipofsky stores and Kunze Saloon. In the distance the Schoppe Store and the Batterman Building can be seen. All of these structures have been replaced or altered. A newspaper article from January 9, 1931 states that Fred Vogt purchased the drug store and would move it to Comfort and Easy streets and remodel it into a dwelling. The State Bank of Palatine, which was organized in 1919, built an imposing two-story building on the Mosser site and dedicated it on June 6, 1931. During the Depression, the bank closed, supposedly temporarily, on July 14, 1932, but it never reopened. Since its demise as a bank, the building has housed offices and, for a while, a beauty school.

The Annex Hotel on the south side of Slade Street between Bothwell and Brockway is being torn down in this 1930 photo. Conrad Fink purchased the hotel and tavern in 1870. After his death in 1875, his daughter ran the hotel with her first husband until his death. Later she married Charlie Seip and they operated the hotel together. The old barn was torn down in 1908 and was replaced with a dance hall which later became the Palatine Theater. Mrs. Seip served supper in the basement during dances. Members of the Athletic Club ate there so often that they renamed the hotel the Annex, because it was next door to their club rooms. This strip of stores replaced the hotel in 1930. There have been a number of different businesses in these buildings over the years. The older building to the west was occupied by Sanitary Market from 1938 until 1992. It was then closed by Charles and Evelyn Buenzow who had been operating the store.

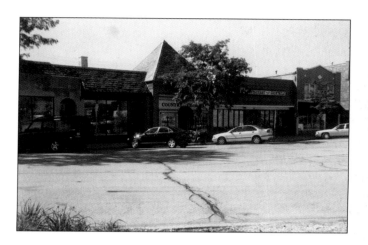

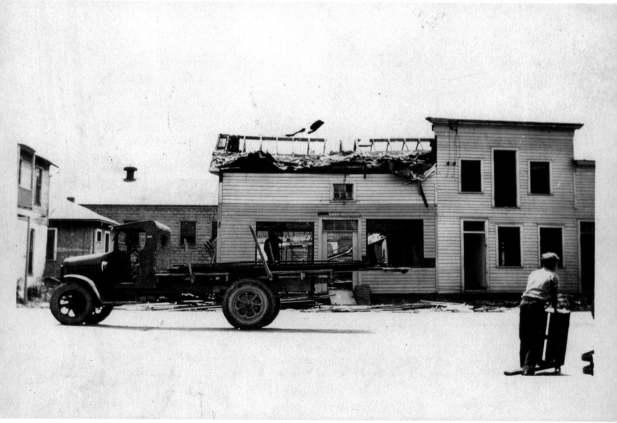

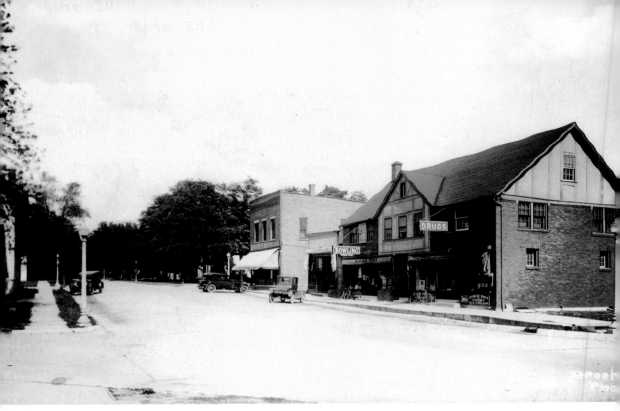

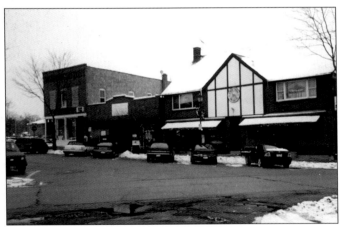

I ra Frye built a "modern livery, feed, and sale stable" in 1901 on this southwest corner of Bothwell and Slade. The facility finally closed because of the growing use of the automobile. Charles Dinse had operated a pool hall and barber shop in the basement of the Batterman Building as early as 1916. He erected this present building block on the Frye site in 1924 to include a pool hall, ice cream parlor, barber shop, and bowling alley. His family also lived on the premises. In June 1947, Jack Wilcox bought the Palatine Recreation Center, as it was then known. He added a cocktail lounge and restaurant and closed the ice cream parlor and barber shop. Later he shut the bowling alley and opened a package liquor store. Durty Nellie's Pub has occupied the premises for many years. The store at the corner of Wilson was Rennack's Grocery and, later, Schmidt Brothers Grocers and Kehe's Market. Mexico Uno Carry-out is now in that building. The other stores have been occupied by a variety of businesses.

George Kuebler stands with a customer *c.* 1900 by the barber pole of his shop, which was located on the rear lower level of the building facing Wilson Street at the southwest corner of Bothwell. The structure, built in 1860, was the first Masonic Lodge. Kuebler came to Chicago in 1874 and plied his trade for 55 years. The first floor of the Lodge was used as a schoolroom during the Civil War. The Masons moved into their new building at Palatine Road and Plum Grove in 1905. During the 1940s, Richard Sanford (who had an insurance agency across the street) operated Dick's Tavern here. This photo shows the rear entrance to the Lamplighter Inn, which has occupied the premises for a number of years.

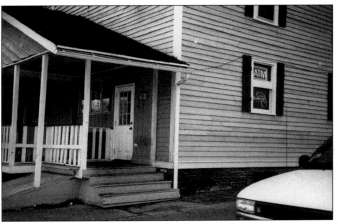

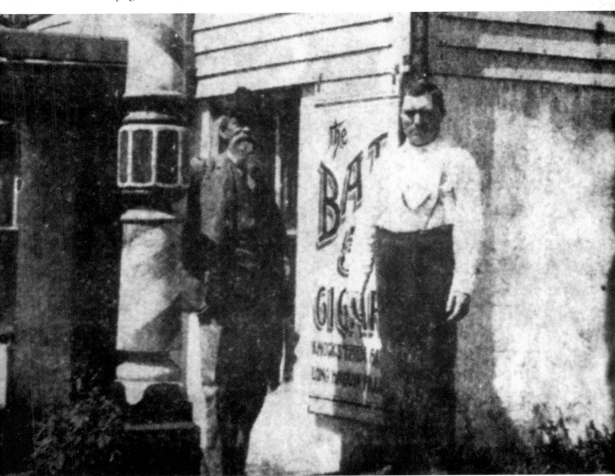

Frederich Thies operated a general store during the latter part of the 19th century in this 1867 house on the southwest corner of Bothwell and Palatine. Fred and Ramona Harmening and Roy and Clara Rowman occupied the house in 1929. Fred was a mechanic and railroad watchman, and Roy served as a captain in the Palatine Police Department. The house was moved to 216 West Wilson in 1957 to make room for the municipal parking lot that was built the next year. Dr. Charles Mankenberg, an optometrist, lived in the house before and after it was moved. He conducted his practice in the building at the rear, which had a 16 S. Bothwell address. In 1967, Bob and Kay Kopecky purchased the house from Mankenberg. They also opened Nelson's Bo-Kay Shoppe in the 16 South Bothwell building in 1971. It can be seen behind the parking lot in this photo, and is now occupied by Thomas Lyle & Co. The Kopeckys have retired from business but are still living in the house on Wilson.

At the west end of the present municipal parking lot (southeast Brockway and Palatine) stood the home of Mrs. Gerhard Schoppe. The mother of Henry and Louis, who owned the Schoppe Store, lived here from 1892 until 1935. Since the streets appear to be paved in this photograph, it would date after 1925. Her son Henry Schoppe sold International Harvester farm equipment and Ford and Oakland cars on the property until World War II created shortages. The auto garage in the rear with a South Brockway address became the Cork and Bottle after the war. The house and barn were removed and replaced by the parking lot in 1958. Dobby Dobkin purchased the beverage company in 1963 (seen here behind the parking lot) and operated it under the name of Foremost Cork and Bottle. He acquired the post office building to the south after it was vacated in 1971 and enlarged his store. The name was changed to World Wide Liquors.

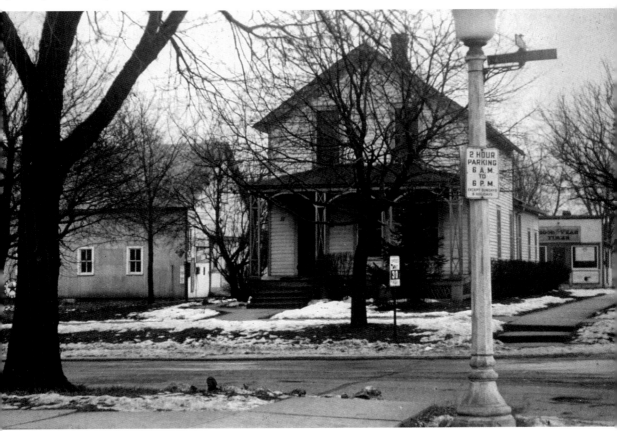

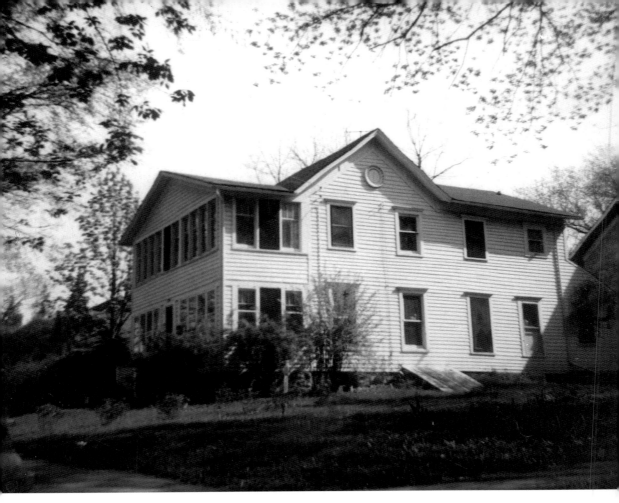

Palatine, believed this was possibly the first house built in the village. The Thurston family came from Vermont as early as 1855. Father Hiram was a carpenter and probably did most of the building himself. The Thurstons were gone from Palatine early in the 20th century, and other families, among them the McMullens and the Steffens, occupied the house. Eventually it was torn down and replaced with this office building, which houses a variety of enterprises including insurance, engineering, medical, management, and accounting firms.

The Thurston house was located on the east side of Bothwell, south of Palatine Road. In his memoirs, Joel Wood, who surveyed and platted central

On November 20, 1904, a cornerstone ceremony was held for the new Masonic Temple of the Palatine Masonic Lodge 314 AF and AM. The building was dedicated on April 29, 1905 and still serves the Masons. The group was formed in January of 1859 and held meetings on the third floor of the hall at Wilson and Bothwell. Eventually, they purchased that portion of the building for $800 and in 1881 they bought the lower portion and leased it to a barbershop. The first Lodge building was sold in 1903 for $1,600, and the site of the present building was purchased for $400. The new facility contained a two-lane bowling alley that was used by the Palatine Athletic Club. This was replaced in 1916 by a larger dining room. At one time, the Palatine Library was located in the building. The cornerstone can be seen on the structure at the northeast corner of Palatine and Plum Grove roads.

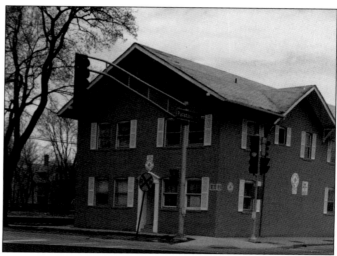

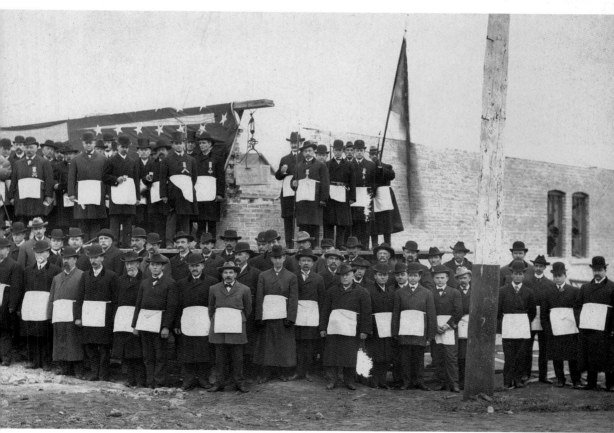

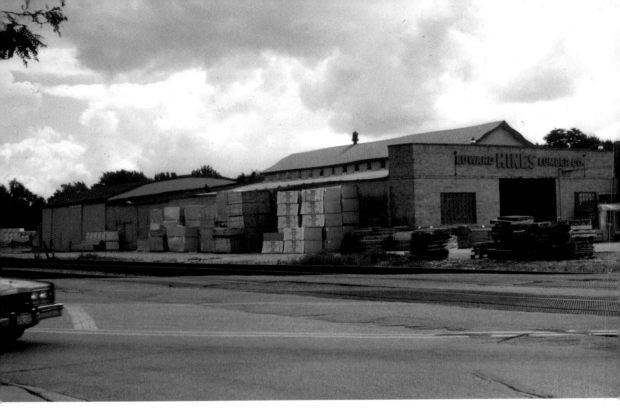

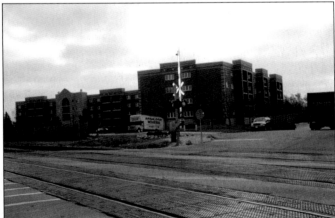

This photo of the Edward Hines Lumber Co. was taken in 1985, but the firm had acquired the Palatine yard in June of 1953. A lumber company had been located on this spot in 1916 (perhaps earlier) when Tibbets Cameron Lumber Co. advertised in the 1916 Cook County Fair booklet. Tibbets Cameron continued doing business at this location into the 1950s. Neither Tibbets Cameron nor Hines Lumber were owned by local businessmen. Wellington Partners acquired the site to build a condominium complex in 1996, after Hines had closed the operation. The first unit in Miramonte Pointe was sold in the Fall of 1997, and the sale of all apartments was completed in the Fall of 2000.

Anna Hornbostel and her children, Mildred and Irwin, are walking down the PLZ&W tracks (Palatine, Lake Zurich and Wauconda) *c.* 1914. They were on a fishing expedition to the Converse Pond which was located near Baldwin (Northwest Highway) and Quentin roads. The Hornbostels lived in Chicago, but were probably visiting Anna's parents, William and Wilhemina Kunz. Anna grew up in Palatine and was married at Immanuel Lutheran Church.

Chapter 2
AROUND TOWN

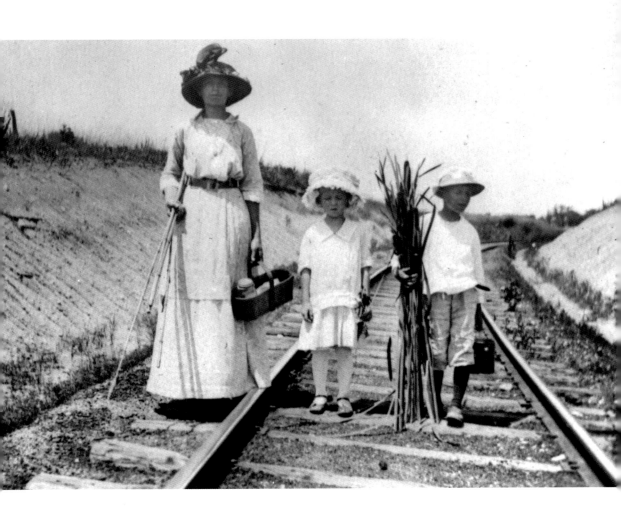

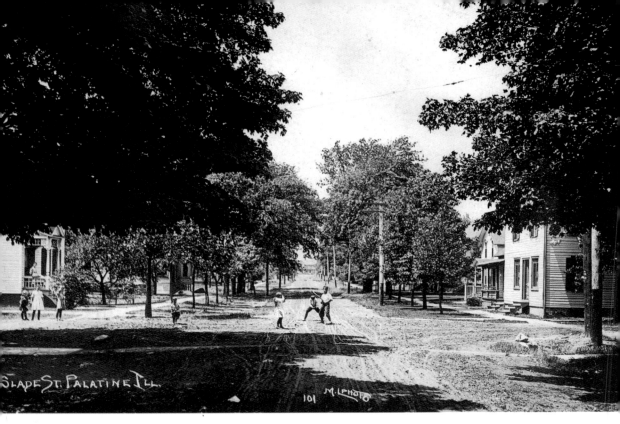

Slade St. Palatine Ill.

101 M.L. Photo

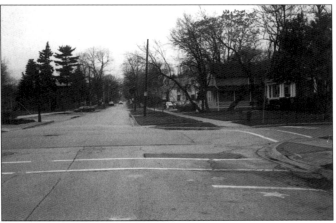

This *c.* 1910 photo of Slade Street looking west from Greeley is of particular interest because of the little girl standing on the left who is participating in a baseball game. She is Florence Parkhurst, historian-extraordinaire of Palatine. Her grandfather Richard Lytle was born in Palatine in 1839. Her great-uncle Myron Lytle was the first mayor of Palatine. Her father, Albert G. Smith, was active in the community. Florence and her eight siblings were born in Palatine, and in 1980, all of them were still living in Palatine. The names of families who are related to her can easily be recognized on street signs and buildings in Palatine. Florence recorded data, clipped articles, and kept extensive records of Palatine people. The Palatine Historical Society is greatly indebted to her. After her death in 1984, the room that houses the Society's historical records was named the Florence Parkhurst Memorial Library. Today, this piece of Slade Street, which is only a block from downtown Palatine, still remains residential.

The Immanuel Lutheran Church, in the background on Plum Grove Road, was built in 1914. This photo was probably taken during World War I. It is not known when the house on the corner of Wilson was built, but it was purchased in 1894 by Thomas Van Horne and his wife Clara. The house was known as the Greener home because it was deeded to the Van Horne's only daughter, Grace, and her husband, Marvin Greener, in 1929. Grace was well known in Palatine. She was active in many organizations and taught school. Grace Greener died in 1980 at the age of 90. The Plum Court Condominium, which replaced the Greener house, was built in the late 1990s by Wellington Partners. The company also erected the condominiums on the site of Hines Lumber Co.

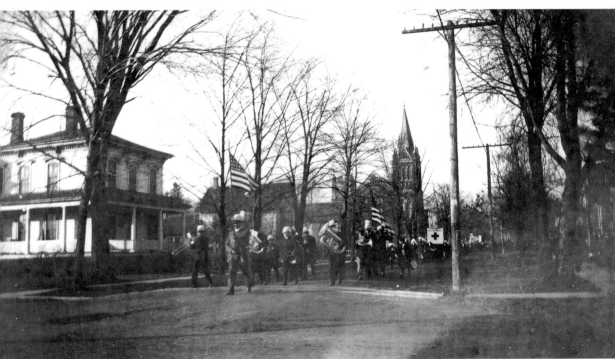

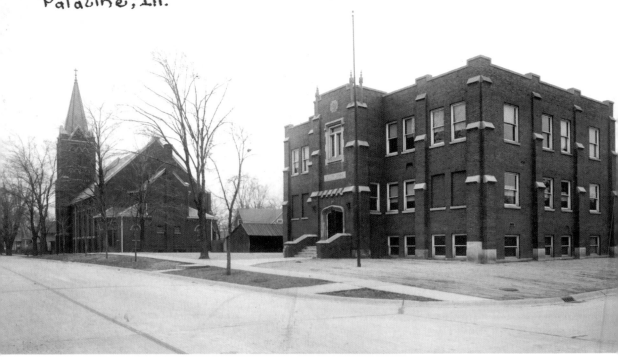

utheran School & Church.
Palatine, Ill.

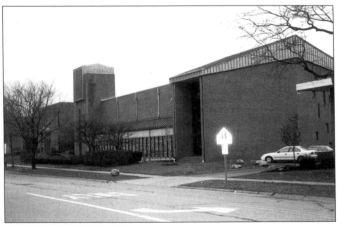

The Immanuel Lutheran School located on the west side of Plum Grove Road, north of Wood Street, was built in 1926 on the site of the first Lutheran wooden church, which had been purchased in 1869 from the Disciple's Church. A new brick church was built to replace the wooden one in 1914, on the corner of Wood and Plum Grove. The church continued buying property on the block, first acquiring the corner of Wood and Bothwell in 1946, then property north of the school on Plum Grove in 1955, and expanding that area to Bothwell on the west in 1968. The present church was built in 1970 north of the school building, which had been expanded in 1957. The 1914 church was razed and the site is now a playground. The 1926 school was torn down and replaced in 1978 by a building that included a gymnasium, meeting rooms, cafeteria, and educational facilities. The church, the 1957 school building, and the enlarged school can be seen in this present day photo.

The Village of Palatine and its citizens enjoyed a very good year in 1906. That is when Bowman Dairy, which operated other plants in the Chicago area, opened this modern facility on the east side of Smith Street at Wood. It was a big boon for area farmers who could bring their milk directly to Palatine instead of bearing the expense of shipping by rail, and the cost of equipment, and cleaning. After Bowman closed this facility, it was occupied by other businesses. In 1930, Economy Fuse acquired the building as a plant of approximately 20,000 square feet for the production of plastic material and plastic products. In the early 1970s, the building was razed and the Wood Street Apartments, later named Park Towne Apartments, were built as rental units. The "Apartments" became "Condominiums" in 1998 with the sale of all the units completed in the summer of 2001.

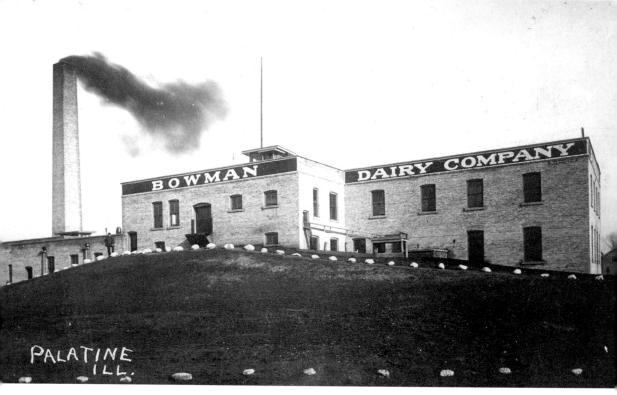

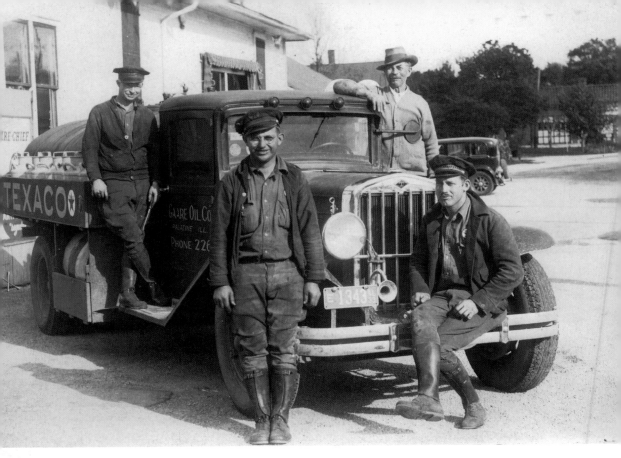

Around 1925, the Gaare Oil Company, a Texaco station, was built on the northeast corner of Smith and Colfax streets on property owned by the Gaare family when Northwest Highway was routed down Colfax Street. This photograph was taken *c.* 1930s. Otto Gaare operated the station until he moved to Arizona in 1945. The corner remained a service station under other owners into the 1980s. Total Auto Parts built this facility on the site and it is now a NAPA Auto Parts store. The tree-surrounded house in the distance was replaced in the 1940s by a drive-in cleaner that remained there for many years. Since this modern photo was taken, the cleaning establishment has been razed and a large condominium was built there.

This 1917 Fourth of July parade is marching on Colfax Street headed west toward Plum Grove. The Frye house on the right probably dates from 1867. Ira Frye came to Palatine in 1878 and operated a livery stable. His son Fred, with his wife and children, returned to Palatine from Minnesota in 1906 to help his father when he became ill. Fred and his family continued living in his father's house after Ira's death. The house on the left, made of local Kitson brick, was reputed to have been built for two families in 1870. Herman Linneman and his wife Anna were one of the families living in the house. Herman was a highway policeman and worked for the Cook County highway department for 45 years. In 1929, Herman and Anna Linneman and Edward and Emilie Hapke occupied the house. Anna continued living in the house until her death in 1965. The house is known locally as the Richmond Creamery.

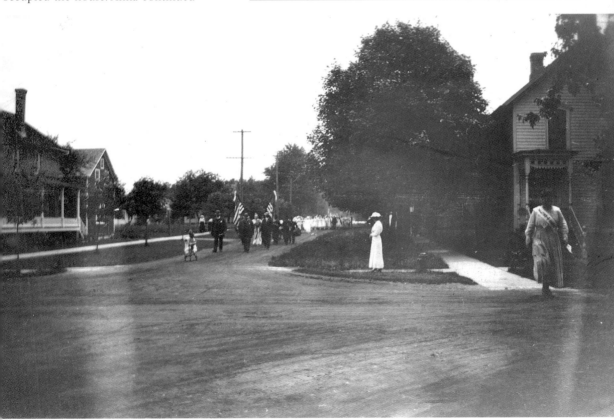

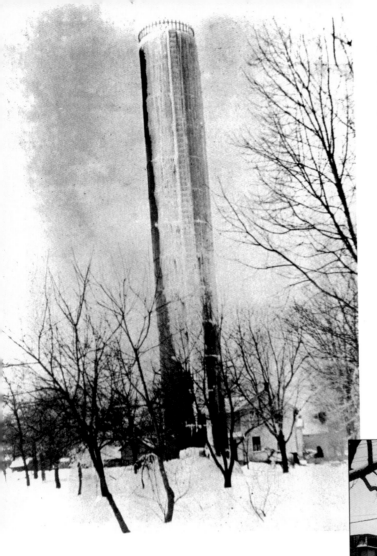

The standpipe stood on the southeast corner of Colfax and Hale Streets for over 30 years before it was torn down in 1928. It was part of the old water works system that had been replaced by a new well, miles of new mains, and facilities in other parts of town. In 1960, a fire station was built on the village property in memory of Wesley R. Comfort Jr. and Leonard Nebel who were killed when their fire truck was hit by a train on the way to a fire. The new station enabled firemen to answer fire calls on the north side of town without the danger of crossing the tracks or the delay of having to wait for a train to pass. The south station on Slade Street was built entirely by volunteer help and money. The Colfax station was the first fire facility erected and equipped using tax funds. In 1974, the station was enlarged and dedicated to all the members of the Palatine Fire Department who died in the line of duty. It is named after Orville Helms, the first full-time fire chief.

This is Hicks Road looking north from Baldwin Road in the early 1900s. The land on either side was not developed until the 1960s when the Willow Creek and Reseda subdivisions were built to the east and north of Baldwin. In the early 1970s, a shopping center was erected on the northeast corner of Hicks Road and Baldwin that included K-Mart, Elm Farm Super Markets, and Walgreen Drug Store. Other grocery firms occupied the store property for a while, but eventually that space was added to the K-Mart and Walgreen has since moved. On the west side, Elmer Gleich had built a 9-hole golf course on 66 acres in the early 1960s. A few years later, there was a great deal of controversy between Gleich, the Village, and Cook County over Gleich's plans to erect an apartment complex. Eventually, the only apartment building on the property was Old Madrid Apartments (now One Renaissance Place Condominiums,) and commercial buildings and the present library were erected on the rest of the site.

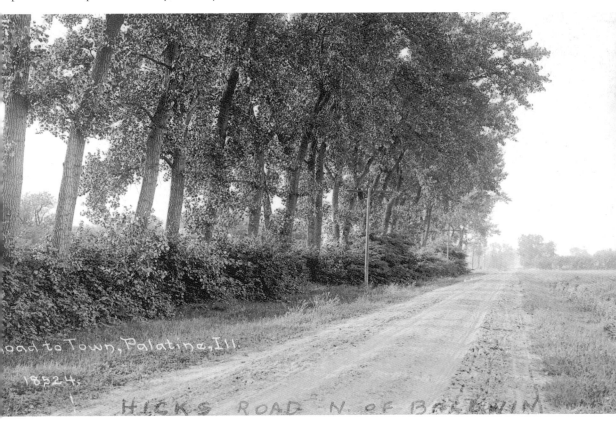

oad to Town, Palatine, Ill.

18524.

HICKS ROAD N. OF BALDWIN

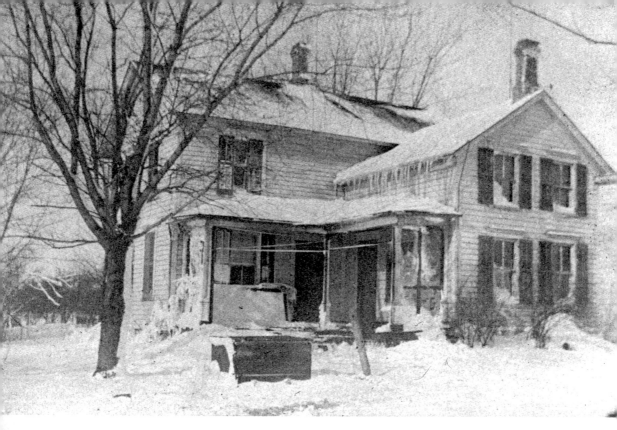

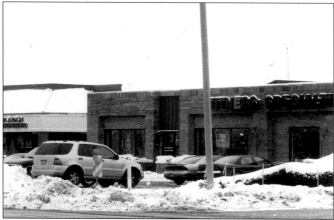

Before this section of road between Hicks and Quentin became Northwest Highway, it was known as Baldwin Road. In fact, some businesses on the street still have Baldwin Road addresses. The Baldwin family came to Illinois by covered wagon from New York in 1844 and soon settled in Deer Grove. There were farms on both sides of the road that bore their name. The family began farming on property on the north side of Baldwin, which is now the Palatine Hills Golf Course. John Gardner Baldwin, one of the sons of John P. and Lydia Root Baldwin, lived on the south side of the road in the house pictured in this early 20th century photo. The house remained until the late 1980s when it was razed to build this small shopping strip which houses Fitness Specialties and other stores. Many descendants of John and Lydia Baldwin continued to live in Palatine and have been active in the community.

According to local historian Florence Parkhurst, this building on the north side of Northwest Highway just east of Quentin was a schoolhouse in the 1940s. It became a restaurant called Radio Club Farm in 1945. At that time, there wasn't much out that way except farms. In the 1950s, the restaurant was called The Supper Club, as seen in this photo. Most Palatine residents remember the business from the 1960s, when it was Uncle Andy's Cow Palace, because of the huge cow statue that sat on the grounds. For a brief time in the 1980s it operated as La Romana (without the cow). That restaurant had been closed for a short time when it burned down in January 1981. In the late 1980s, the Quentin Corners shopping center was built on the property. Now, Ben and Jerry's Ice Cream store sits about where the restaurants used to be.

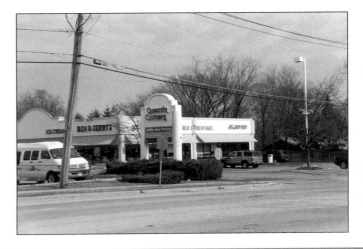

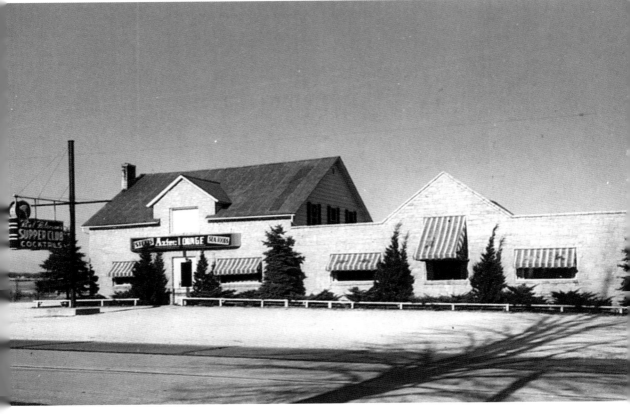

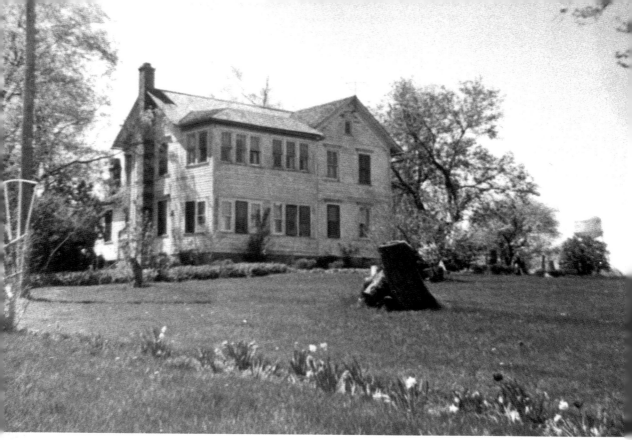

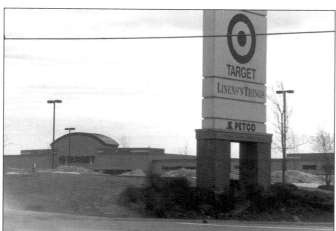

This Sutherland farmhouse, which dates from the 1800s, was still standing when this photo was taken in 1961. Mason Sutherland came from Vermont with his family in 1837 and his wife Nancy Boynton arrived with her family in 1838. They eventually owned 300 acres of land on the south side of Dundee Road between Hicks and Rand roads. During the 1850s, the family moved into town but continued to farm the property. After Mason died during the Civil War, Nancy rented out the farmhouse and eventually sold off the property. In the 1990s, this was the largest piece of open land in Palatine Township and had more than one owner. By the middle 1990s, a shopping center was built on the site. The Target store probably occupies the area where the house sat.

Henry and Engel Schroeder came to Palatine Township in 1865 and began farming in the vicinity of Rand and Old Hicks Road. Their son Fred was born in Palatine in 1874 and continued to live in this house and farm the property until he moved his family to Elgin in 1924. Afterward, Fred's son Emil lived on the farm. When development began on Rand Road in the 1960s, Skrudland Photo built this facility at 1720 N. Rand Road (on the west side of Rand Road, about one block north of Dundee). In the late 1990s, the shop changed hands and is now Flash 1-Hour Photo.

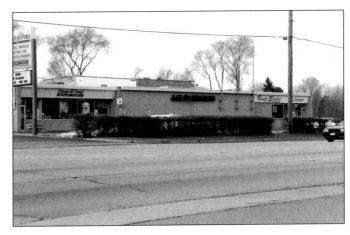

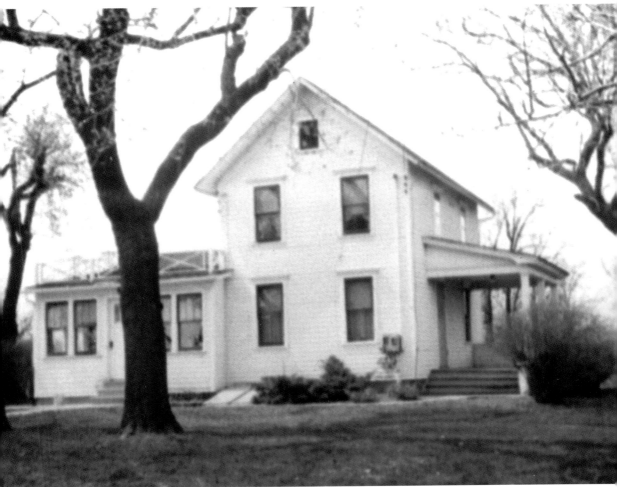

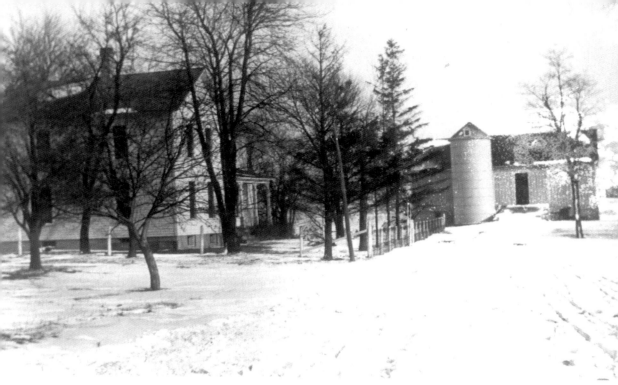

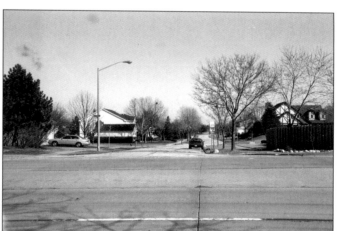

Henry Wente came to America in 1848 and probably settled in Palatine soon after. There were 10 children born to his two wives, and the Wente family operated farms on both sides of South Quentin Road. This photo of the Wente farm was probably taken in the 1920s or 30s. The driveway was located on the east side of Quentin Road directly opposite the bleachers of the present Fremd athletic field and became a street called Medford Drive. The oldest Wente son, Charles (who also had 10 children), was a successful farmer, well digger, and dealer in windmills, pumps, engines, and farm machinery. Since many of the Wente children remained in Palatine, they have been associated with a number of businesses and institutions in the area. The housing development, which replaced the farm, was built in the 1970s.

The 1874 water reservoir on the east side of south Brockway and Washington streets was replaced with the water works shown in this 1919 photo. A new municipal building was erected here in 1929 to replace the one on Slade Street. The new structure was described in the *Enterprise* newspaper as "one of the finest of its kind around in these parts and is a credit to the progressive spirit of the village." All the village offices were located under one roof and there was garage space for fire engines. A separate police facility was built behind it on Washington Street in 1964. In 1977, Palatine High School moved to its new building on Rohlwing Road. The old Palatine High School on Wood Street became available, and the village, along with the park district, purchased the facility and moved operations there. In 1986, the Tamarack retirement complex of 135 one-bedroom apartments, the first of its kind in the village, was built on this site.

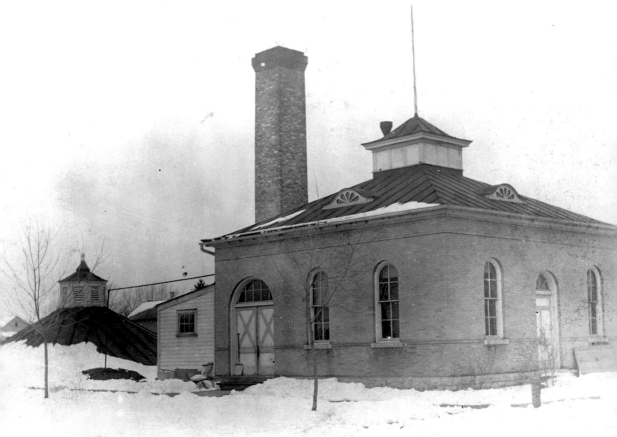

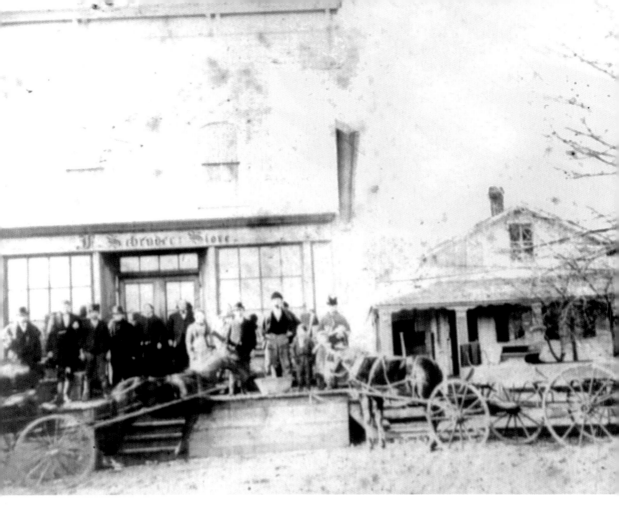

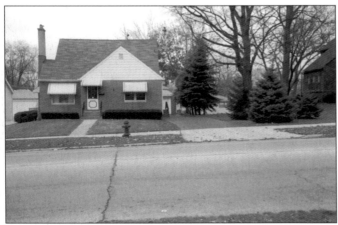

Frederick Schrader operated this store at 122 South Plum Grove Road before the railroad came to Palatine. The family lived in the house next to it at 116 South Plum Grove. Late in the 19th century, the store was moved to South Bothwell Street and became a two-flat. Members of Fred Schrader's family, Louise Schrader, widow of his son Fred, his daughter Cora Schrader, and daughter Laura and her husband Charles Thorp, were still living in the home at 116 in 1929. Another son, Herman, was a lamplighter and one of the first policemen in Palatine. The original house has been removed and replaced by this modern bungalow.

This wintry photo of the Glade farm at 400 South Plum Grove Road was taken in 1936, but John and Helene Glade had purchased the property in 1883 from James and Diana Daniels for $8,000. In 1907, the Glades sold the farm to their son Herman for $7,000. The parents were listed as living in Wheeling Township at the time. Herman and his wife, Selma, farmed the property. The farm was auctioned in May of 1957 and the area was developed. Herman Glade lived in the house until his death in August of 1958. The house and garage building still stand among more modern homes.

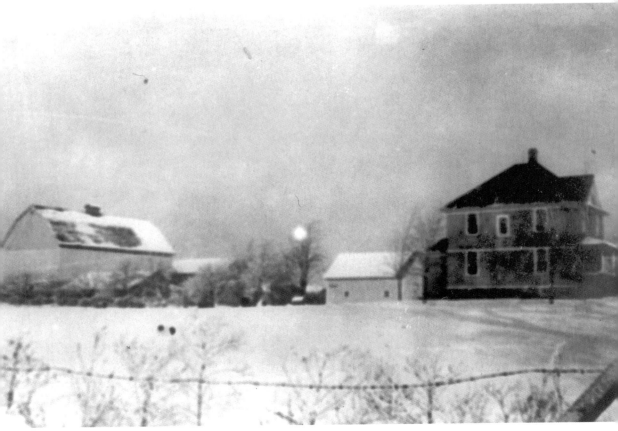

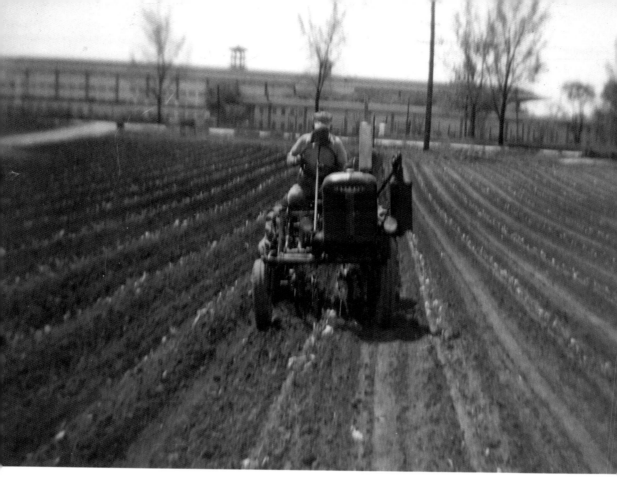

In about 1882, Henry Wilke purchased this farm on Northwest Highway across from the Arlington Park Racetrack. The old race track grandstand can be seen in this *c.* 1949 photo of the farm, where cabbage is being cultivated. The road bordering the east side of the farm is still known as Wilke Road. Development of the property began as early as the 1960s. A building at 1300 East Northwest Highway held a Korvette's that was first replaced by a Zayre's discount store in the 1970s, then by a McDade & Co. catalog store. The United States Postal Service wanted to build a processing and distribution center at the address, which the Village opposed. Eventually, the postal facility was erected. This present day photo is taken from the east driveway of the building, looking toward the 1989 grandstand of the racetrack.

The Cook County Fair originated in Palatine in 1913 when it was held in the center of town. The next year, activities also took place at this site on the east side of Northwest Highway, north of Lincoln, where Dean's Race Track was located. The fair was soon moved entirely to the Dean property, as shown in this 1922 photo, and continued to be held there into the late 1920s. The area became known as Fairgrounds Park. When Roger Ahlgrim built the Ahlgrim & Sons Funeral Home facing Northwest Highway in 1964, a housing development had already been established in Fairgrounds Park. The Palatine location of the funeral home was the first suburban facility to be built by the family-run Chicago company, which is now 110 years old. With a sense of humor, Roger Ahlgrim built an "eerie" miniature golf course in the basement, which is free to the public by sign-up. However, play may be cancelled suddenly if funeral business needs to be conducted.

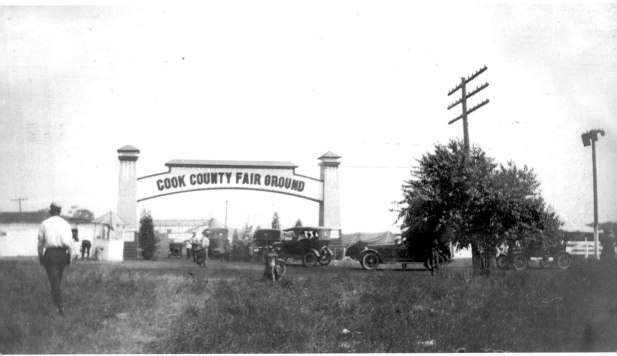

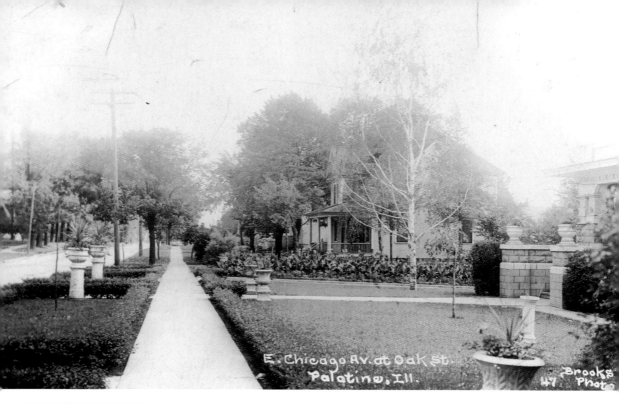

E. Chicago Av. at Oak St.
Palatine, Ill.

Brooks Photo
47

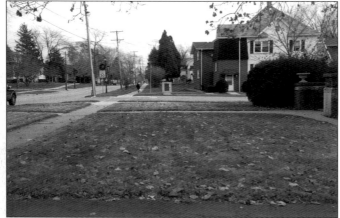

Looking east on the south side of Palatine Road from Oak Street (which doesn't extend south), the steps of the Oltendorf home and the Wildhagen and the Kleinsmith/Cordes houses can be seen. This photo probably dates back to the 1910s or 1920s. Henry Wildehagen delivered mail on the first rural route #2 from 1904 until 1935. He was still living in this house at #205 when he died in 1949. Elma and Henry Cordes shared the home at #217 with her parents, Emma and Charles Kleinsmith, from about 1922. Henry Cordes operated a shoe repair store at 19 North Bothwell. He and his wife were living in the home when he died in 1966. An addition was made to the #205 house, creating an apartment building, and additional apartments have been erected behind it. The Cordes house, at #217, is still standing.

The colonial revival house at 329 North Plum Grove was built in 1907 by Ralph Peck, an attorney, banker, and community activist. He married Caroline Kirchoff who was well known in Palatine for her whistling solos. The whole block between Richmond and Sherman and Plum Grove and Bothwell was part of James Wilson's nursery until 1903. Only two houses were built facing Plum Grove Road on this block, and both still stand. The Hutchison Hart home and barn can be seen to the left.

Chapter 3

HOUSES

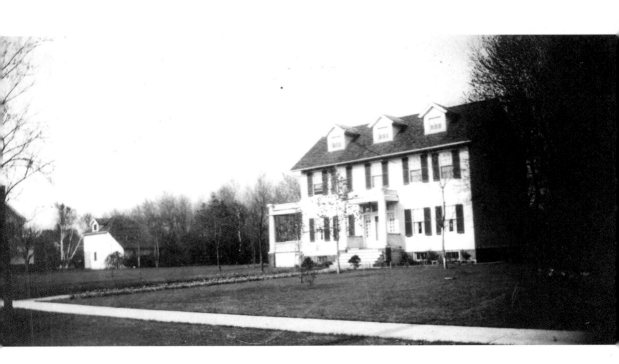

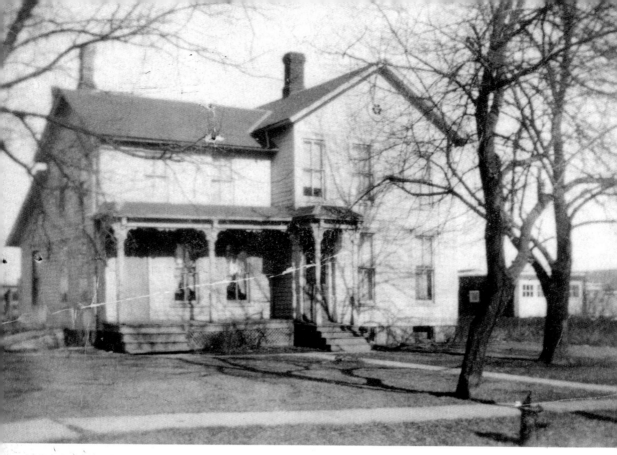

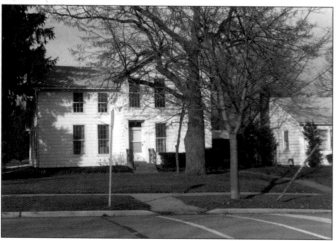

R ev. Thomas Wilson, a circuit rider, came with his parents to a farm in the vicinity of Baldwin and Roselle Roads in 1838. His son John, a veterinarian, bred and trained carriage horses on the farm. John Wilson built this house in town at 356 West Slade Street (northeast corner at Cedar) when the farmhouse burned. He also built Deer Grove Park for the public on the east side of Quentin Road, north of Dundee, which became the first section of Deer Grove Forest Preserve. He died at his son Ben's home in Woodstock, Illinois in 1917. The house pictured here in the late 19th century has been known as the Ben Wilson home, but it is not certain that John's son Ben lived here. However, John's son Ray lived with the family in the house at various times. In 1929, Daniel and Bridget Healy, both immigrants from Ireland, occupied the house. John and Bride McHugh reside in this house in 2002. Bride is the daughter of Daniel and Bridget Healy.

This house at 148 West Palatine Rd. (north side between Greeley and Smith) was owned by Ed and Minnie Dammerman. Before they moved to Palatine in 1921, they had resided on a farm in Schaumburg where Ed's father Henry F. Dammerman had settled. Ed died only a month after moving into his new house. Minnie Dammerman and her son Henry, with his wife Amanda, continued living in the home. In 1974, Henry, a widower, moved to property he acquired at 311 West Wilson, in a deal with Palatine Savings and Loan Association. The firm, which had located at the northwest corner of Palatine and Brockway Streets in 1961, acquired the Palatine Road house and other nearby property. The company razed the entire block between Greeley and Smith and Palatine and Slade Streets to create a parking lot. Among the houses that disappeared were the Batterman and Abelman homes, which stood next door to each other facing Slade Street. H.C. Batterman had built the three-story brick

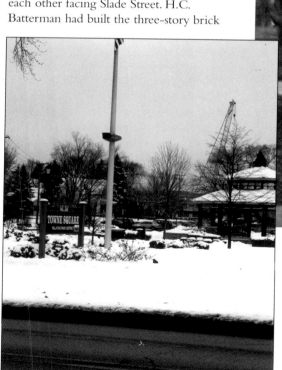

block on the triangle in the center of town and had later given it as a Christmas present to his grandsons, Dr. Henry and Mr. William Abelman. The Village of Palatine made use of the parking area for the Taste of Palatine festival and other events. After the Palatine Savings and Loan Association closed, the Village acquired the property and created Towne Square Park.

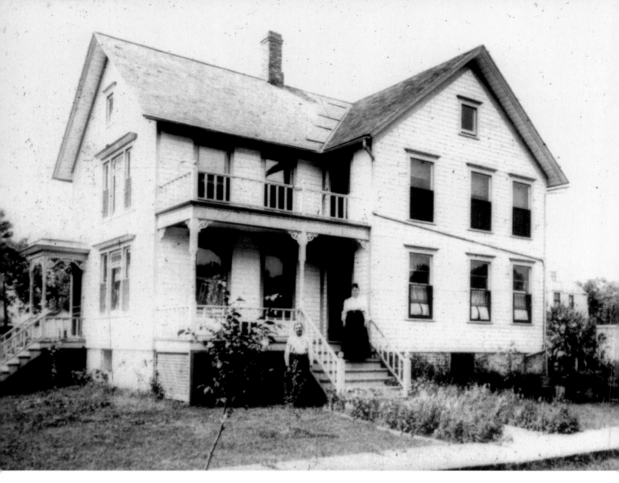

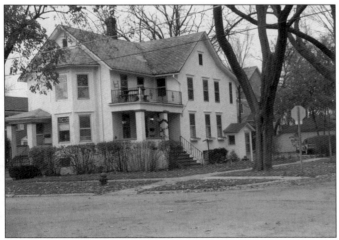

This house at 58 South Bothwell (northwest corner of Washington) was erected in 1904 by William and Caroline Wulff. William's parents had emigrated from Germany in 1867, and he was born in the United States. His wife Caroline was born in Wheeling Township. They remained in the house until his death in 1947 and hers in 1950. In 1929, Helen Meyer, a widow since 1910, also lived in the house. Records indicate that she was a housekeeper for the Wulffs. She died in 1958. A statement in our files indicates that a new house was built on the Wulff's property in 1950. Currently, there is an empty lot to the north on Bothwell and a four-apartment building to the west on Washington at #44. William Wulff left an estate of $10,500 to his wife in 1947, most of it in real estate. The property was possibly sold to someone else who built there.

Henry Mess had a farm in Schaumburg Township when he married Sophie Miller in 1881. The family moved to Palatine in 1910. Around 1920, the Mess's son Otto and his wife Emilie purchased this two-flat on the northwest corner of Palatine and Plum Grove Roads, as seen in this early 1900 photo. Their son Harold was killed in 1940 in an auto accident up the street at the corner of Slade. After Otto's death in 1959, Emilie continued living in the house until her death in 1972. Their daughter Elsa Mess still occupies this house at 4 North Plum Grove Road.

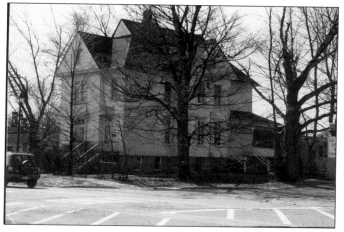

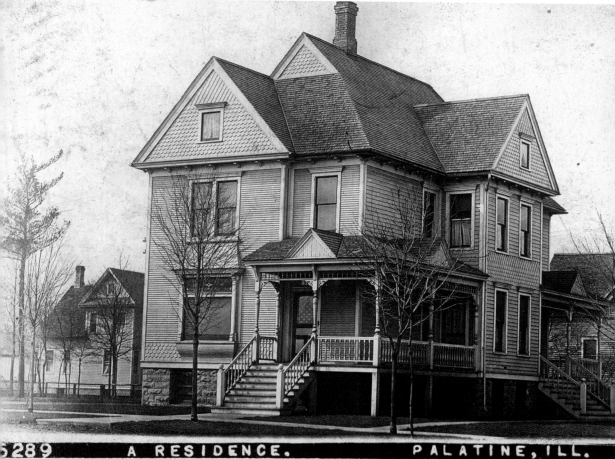

289 A RESIDENCE. PALATINE, ILL.

set back from the street. Andrew's mother Emma also came west with her son and his family.

The Harts had three children, Lottie Emma, Horace Hutchins and Thomas C. (The Horace Hutchins Hart house is described elsewhere in this book.) Lottie and Thomas never married and, with their mother, lived in this Palatine Road house until their deaths. When the first Palatine Library was formed in 1923, Lottie became the librarian. She served in that capacity until her retirement in 1950 due to ill health. By 1960, the Hart house had been acquired by St. Paul United Church of Christ (located nearby), and the building was torn down in 1964 to create a parking lot.

Andrew and Charlotte Hart came from the East to Austin, Illinois in the early 1880s. Shortly thereafter they moved to this house at 200 East Chicago Avenue (Palatine Road) near the intersection of Oak Street. The house was

Edwin Oltendorf had purchased the Ehlers property on the south side of Chicago Avenue at Oak Street in 1917. Since the 1920 census shows him as a "renter," this house was probably built in the 1920s. Edwin was born in Bartlett, Illinois. He married Ida Strand in Wisconsin, and the couple moved to Palatine. Edwin was a contractor who built many of the large roadways in the area. He served as mayor of Palatine from 1931 to 1933. Because of Edwin's poor health, the couple moved to Hot Springs, Arkansas in 1936 and later to Shreveport, Louisiana. However, after their deaths, their bodies were returned to Palatine and buried in Rand Hill Park Cemetery. The house has been used as a commercial property for a number of years and is now occupied by an attorney.

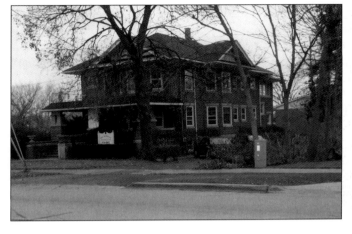

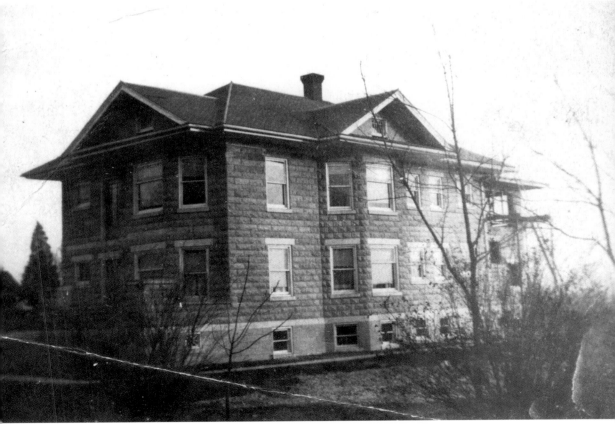

Herman and Anna Pahlman moved into this home at 60 East Slade Street shortly after their marriage in 1874. The house consisted of a living room, dining room, kitchen, and three bedrooms. They both grew up on farms in the northern portion of Palatine Township. Henry and Anna lived at the Slade Street address until their deaths in 1929. The house was then occupied by members of the Pahlman family until 1948. The 1942 phone book lists A.J. Joers at this address. He was the husband of a Pahlman daughter, Rubie. Herman's son Henry was mayor of Palatine in 1921 and 1922. A notation on this photo says "Grandpa Pahlman in front of his house," which would probably date the picture in the 1920s.

Ben Wenegar was a builder like his father Jacob. He erected this home at 24 East Slade Street in 1908. A newspaper article stated: "This is the first building of its kind (cement) in Palatine. It is conveniently and artistically arranged inside and the exterior, especially the porch, has made a hit with everybody." Ben is most remembered for building the brick school on east Wood Street in 1912, which has since been torn down. After his death during the influenza epidemic of 1918, his widow Bertha took in boarders in order to support her four children. She was known as a "fine cook." She was living in the house with her unmarried children, Elmer and Florence, in 1929. Her daughter Maybelle married Harrison Kincaid, the Palatine High School teacher who instituted a sports program for the school and coached a winning basketball team. The house was probably sold by the Wenegar estate in the 1950s.

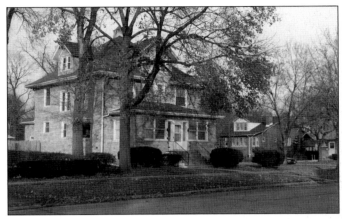

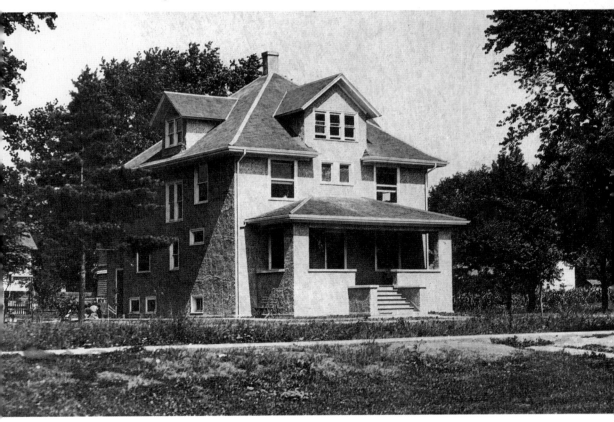

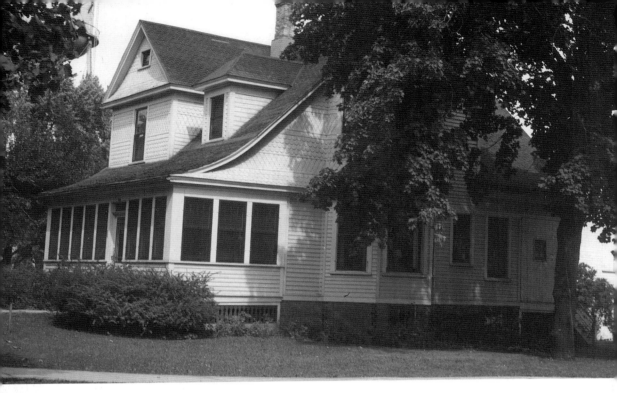

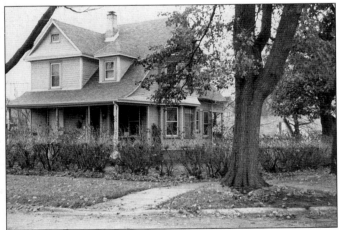

The Julian house located at 203 North Hale (northeast corner at Wilson) was built by Elmer Robertson. During his ownership, Robertson purchased the old frame First Methodist Church (on Plum Grove Road) and had half of it moved behind the Hale Street house to be used as a pigeon loft. He raised and sold pigeons, which were used for food. Charles E. Julian and his wife, Amanda, first rented the house in 1904 and then purchased it. They lived there until they died. Amanda passed away in 1936 and Charles in 1946. Charles operated a cheese factory at Kitty Corners (Rand and Dundee Roads). He was later active in Republican politics and worked for the sheriff's office.

James Thomas Daniels married Belle Fosket in 1882. She was a granddaughter of Ezekiel Cady, an original Palatine settler. When James died in 1945, his obituary stated "the marriage service was read in the same residence in which he died." However, the couple had moved to a Daniels' farm in Iowa soon after their marriage and then to Elgin, where he worked in the clock factory. The family returned to Palatine in 1906. James was a mail carrier in Palatine on Route One until his retirement in 1929. At the time of his death, he was a widower living with his daughter and son-in-law, Zelda and Daniel Bennett, in this house at 36 West Wilson (northwest corner of Bothwell). Zelda was the first regularly employed telephone operator in Palatine, a position she held for 40 years.

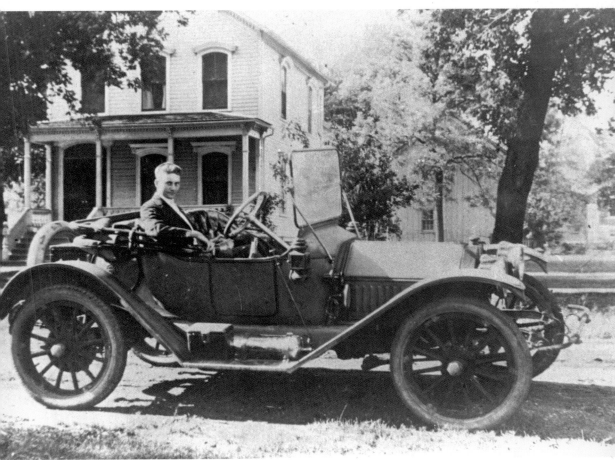

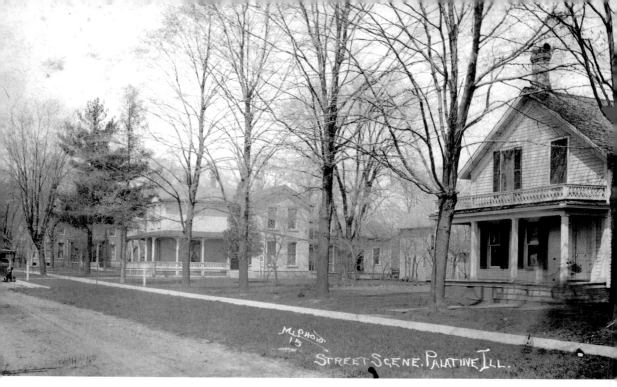

Street Scene, Palatine Ill.

Timothy Dean built this house at the northwest corner of Wilson and Plum Grove *c.* 1863 and later moved it to 105 North Bothwell (northeast corner of Wilson). The Greener house and, recently, Plum Court Condominium were erected on the original site. James McCabe bought the house on Bothwell in 1872. He worked for the railroad and spent a good deal of time in St. Paul, Minnesota while his family remained in Palatine. His daughter Helen Adelaide (Addie) married John Swick, and they continued to reside in the Bothwell house. James McCabe returned to live with his daughter Addie in the Palatine house after he retired. She died in 1942, having lived in the same house in Palatine for 70 years. The parking lot seen here is on the east side of Bothwell and extends from Wilson to Wood Street. It includes the McCabe/Swick site, and was acquired by Immanuel Lutheran Church in 1979. The building seen here houses the clothing bank and food pantry for Immanuel's Good Samaritan Ministries.

Henrietta Schirding built this large home at the northeast corner of Wilson and Brockway in the 1880s and another behind it at 123 North Brockway in 1903 for her children, Mathilda House and Dr. William Schirding. A 1929 aerial photo shows that the big house had already been removed. The location remained undeveloped for many years. Jewel Tea Company opened its first Palatine grocery store on the site in the 1950s. Later, businesses in the facility included the Ben Franklin Store and an S&H Green Stamp store. King Cleaners and Mia Cucina Restaurant occupy the building now. Martin Plate lived in the 123 North Brockway house for a number of years, from about 1927. In 1977 it became the home of Rita Mullins, current mayor of Palatine. For a while she operated a store, "Aunt Teaks," on the first floor of the 13-room house. In the spring of 2002, the house, zoned "commercial," is being sold.

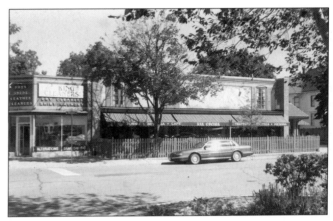

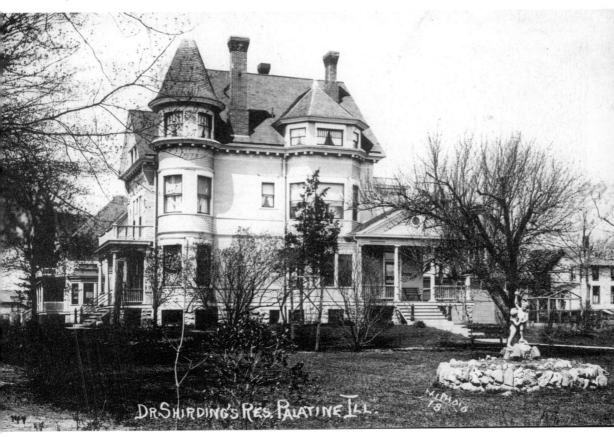

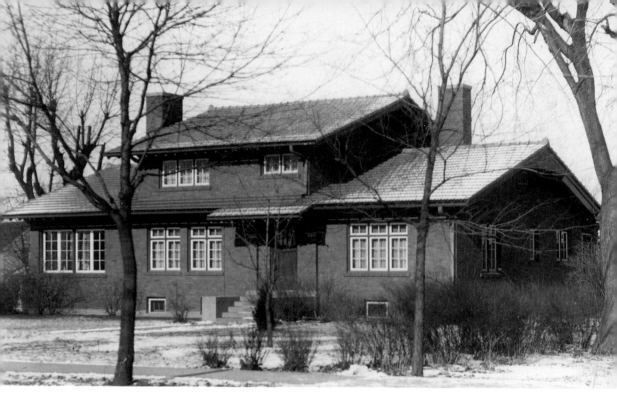

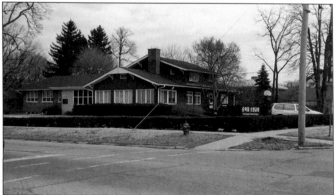

William G. and Amelia Ost lived in this house at 149 North Brockway (northeast corner of Wood Street). It was built after an older house was removed. William Ost operated a flour mill from 1906 until 1929. He was president of the Palatine High School Board and chief of the Fire Department. Ost Field at the old high school was named after him. After his wife's death in 1957, the property was purchased by the Palatine Library. A $125,000 referendum allowed for the purchase and remodeling of the house and grounds and an addition designed to house a reading room and book collections. In 1962, the basement of the addition was remodeled to become the children's section. In 1975, a new library opened on Benton and Northwest Highway, and the Unitarian Universalist Church occupied these premises until they erected a new facility on north Smith Street. The Full Gospel Church of Hope is now located in the building.

In 1883, Morton and Clarinda Cady Pinney moved into town and purchased this house at 222 North Plum Grove Road (southwest corner at Colfax.) They had rented out their farm at Ela and Baldwin Roads where they had grown various crops including tobacco. Clarinda's parents had settled on a knoll on Ela Road near Dundee in 1837. A year later, Clarinda had the distinction of being the first white child born in Palatine Township. The first cemetery in the Township was the Cady cemetery on the Cady property, and the first school was held in their log cabin in 1841. The widowed Clarinda was residing in the house on Plum Grove with her daughter Addie when she died in 1932. The Plum Grove Dental Center was erected on the site *c.* 1970.

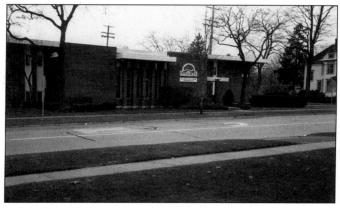

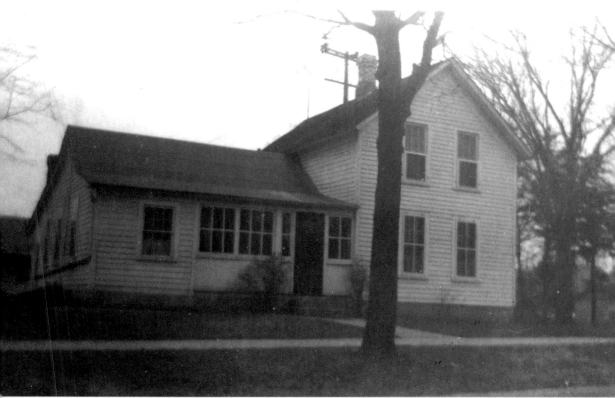

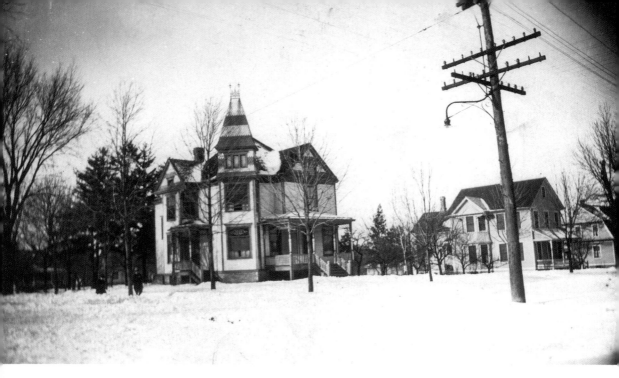

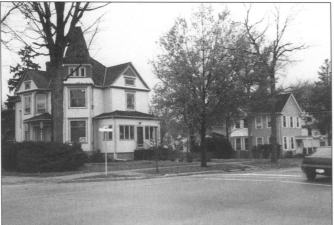

Edwin and Zilpha Converse lived on a farm located on both sides of Baldwin Road (Northwest Highway) at Quentin Road after their marriage in 1880. In 1885, they moved into town and built this elegant French-style house on the northwest corner of Plum Grove and Colfax. When their daughter Rose married Rufus Starck in 1908, the young couple purchased the house, but they did not live there very long. In 1929, the house was occupied by John and Emma Stempl. During the 1950s, a nursing home was operated here. Harry Benstein had an insurance agency there from the 1970s until the late 1990s. In 2002, a law firm owns the property. For many years, the house shown next door was the home of Frank Regan, a former president of the Palatine Historical Society.

William and Minnie Toppel and family moved into town from a farm outside Palatine in 1918. They probably bought this house at that time from Jacob Barbaras. Exactly when Barbaras first occupied the house is not known, but it may have been as early as 1901 when he "moved the barn from the old homestead to his present place of residence." William's wife Minnie died in 1919, and he continued to live in the house with his son Albert and Albert's wife Minnie after their marriage in 1920. Albert and Minnie remained in the house until 1960 when he retired as a foreman at Benjamin Electric Company and they moved to Elkhorn, Wisconsin. This photo of the house at 317 North Brockway was probably taken around 1918 or earlier, because there are no other buildings surrounding it.

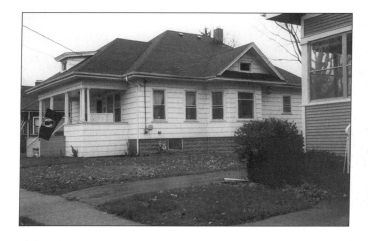

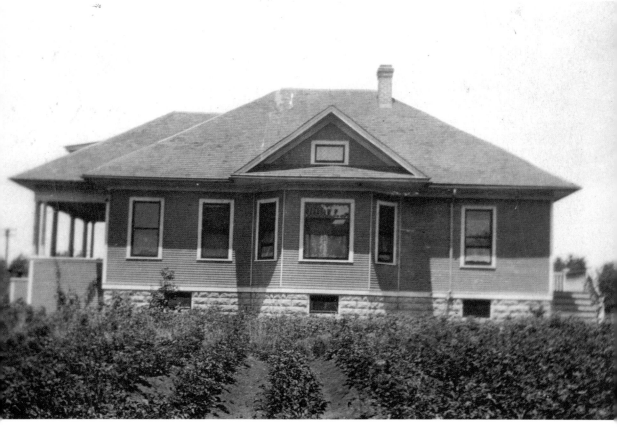

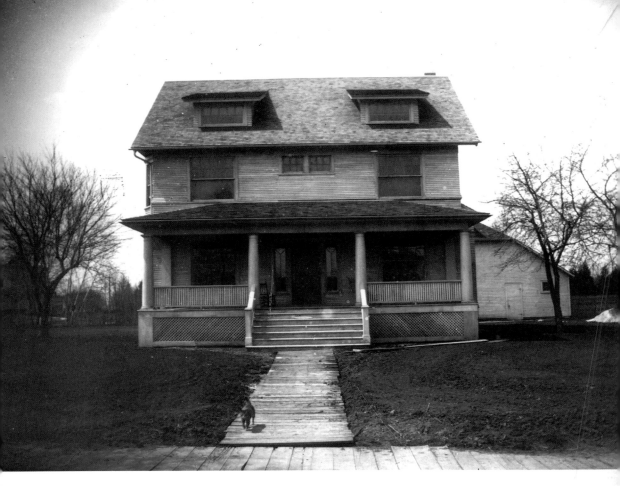

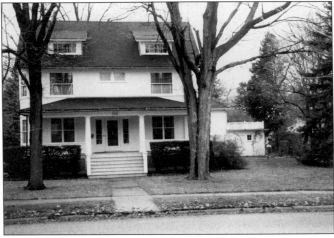

Horace Hutchins ("Hutch") Hart and his wife June both graduated from Palatine High School in 1893 and married in 1901. They built this home at 308 North Plum Grove (on the northwest corner of Richmond) in 1906. A newspaper article describes it as "a modern residence that equals any of its size in town with a barn that makes the whole a home to be proud of." The "barn" building still stands, though it has been modernized and added to. Horace, a broker, was president of the James R. Baker Company in Chicago. Before his marriage, Horace had lived with his parents and siblings, Lottie and Thomas, in the house at 200 East Palatine Road that is also described in this book.

Peter Knowe and his wife Elizabeth came to Palatine in the 1890s from the East, at the urging of local resident Charles Patten. Peter Knowe was a boiler contractor for large projects in Chicago, and he also did cement work, having installed some of the first sidewalks in Palatine in the early 1900s. It is clear that he was living in this house at 31 West Robertson (on the south side of the street, west of Plum Grove) as early as 1901, as a newspaper article that January described how he had beautified his house on Robertson. After Peter's death in 1934, his son Charles and daughter-in-law Madeline lived in the house until the 1940s. It is not known when the house was remodeled or when this large addition was built.

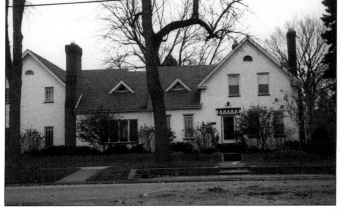

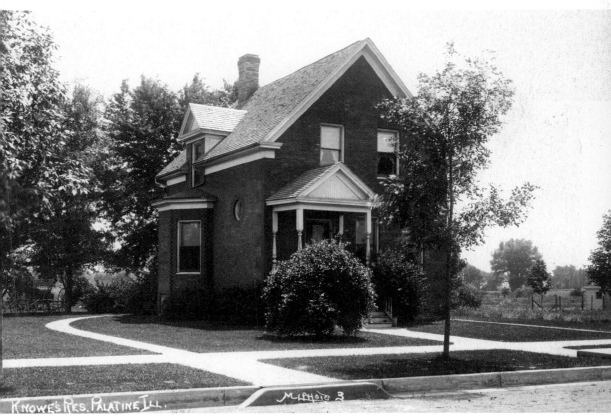

William and Louise Baumann moved into this house at 1152 North Hicks Road in 1913 (west side, south of Dundee). William bought 40 acres of land on Hicks Road and operated a dairy and chicken farm on the property for 55 years. In 1968, he sold all but two acres of the property to Kaufman & Broad, who then developed the Heatherlea subdivision. William Bauman lived to celebrate his 100th birthday in July of 1982. His daughter Edith married William Fremd, for whom Fremd High School was named. William's son Elmer and daughter Ethel, both of whom worked as farmers, never married and currently live in the house on Hicks Road.

After Palatine Township was formed, it was divided into nine school districts, and each district had to provide education for its children. In 1901, Cook County instituted a system of consecutive numbering and Palatine Township schools were designated in the teens. We know that District #6 became #15, the village school. However, we have not yet been able to ascertain which school district the *c.* 1880 District #3 school, pictured here, was renumbered. This chapter will describe the seven one and two-room schools and the Palatine village elementary and high schools that were in existence in 1946 when consolidation of District #15 began.

Chapter 4

SCHOOLS

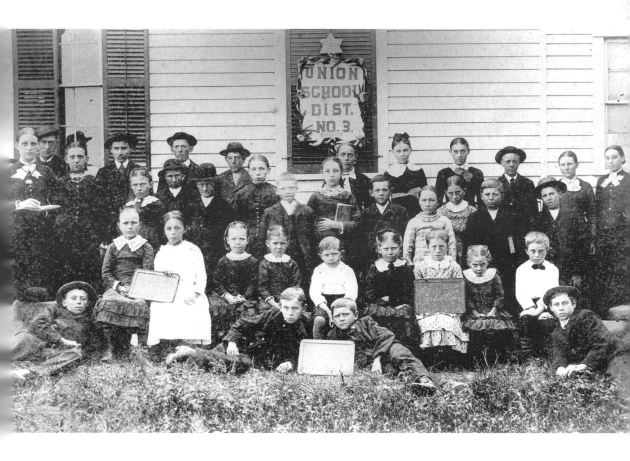

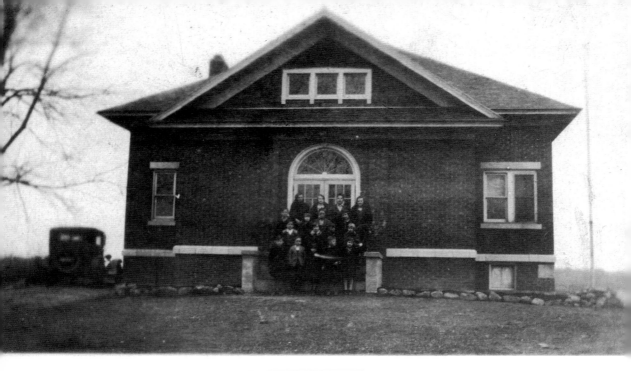

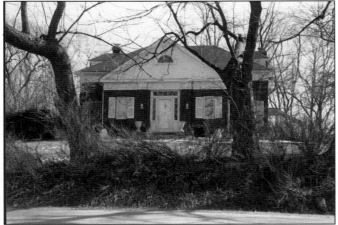

Deer Grove School #12 was located on Ela Road, one-half mile north of Baldwin Road in the northwest corner of Palatine Township. The brick building pictured here was erected in 1926 and, at that time, was the most modern one-room school in Cook County. A new deep well was drilled and provided "running water and modern sanitary conveniences." Electricity was installed. Gas was secured as the fuel to be used in the kitchen so that hot lunches could be prepared for the children. Since this was a small school district (only 13 children), it was quite an achievement for the parents and residents of the area. An earlier school probably had existed, but we have no records concerning it. When consolidation issues arose in 1946, Deer Grove School chose not to consolidate with Palatine District #15. Instead the school joined with the Barrington School district, which was much nearer. The building was sold and is now a home.

Honora McGuire came to Palatine by train in 1903, and got a ride out to the Langhoff's farm to become the new school teacher in District #13, the school located on the Wittenberg (or Wittenburg) farm. The school building predated the 1890s and it was "a poor excuse for a school" for many years. In 1923, a $6,000 bond referendum passed that allowed the district to build a new Wittenberg School for $7500 on the west side of Quentin Road, north of Baldwin (Northwest Highway). The brick school had a "34 x 22 foot assembly room, a cloak room, a sanitary room and a large basement." The boys played baseball in the basement. There were 28 students, the largest school population in the township (excluding Palatine Village District #15).

The new school received many visitors. After the consolidation, it became a home, then an office. It is currently occupied by Liberty Construction Co.

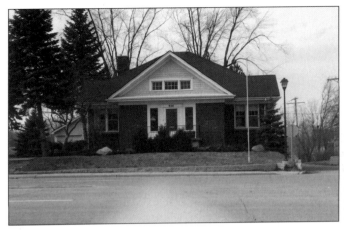

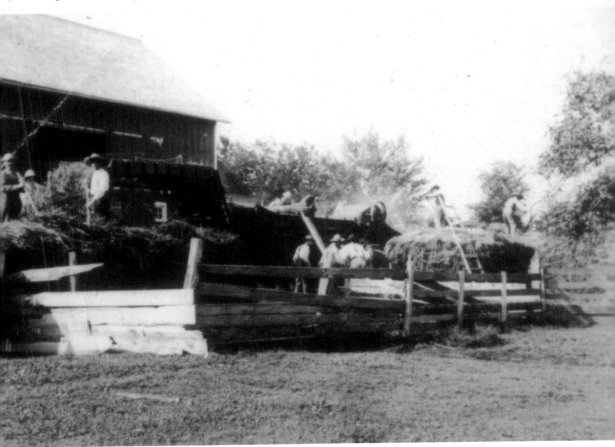

Ethel Baumann was born in 1917 and lived on North Hicks Road. She recalls attending the District #14 Kitty Korner School on the southeast corner of Rand and Dundee Roads. In a May 1916 program, the same District #14 school was designated as Staples Corner School and had an attendance of 24 students. This photograph was probably taken in the 1930s. Two kerosene oil lamps, which hang in the kitchen of the Clayson House Historical Museum, came from the Kitty Korner School when it was razed after the District #15 consolidation. The lights were presented by Mary Csandai, the last teacher in the school. Denny's Restaurant was built on the site in the mid–1970s.

The brick District #15 school seen here on Wood Street at Benton was erected in 1913. A four-room wooden school had been built on this site *c.* 1859. Two rooms were later added to the north side, and the building stood until it was replaced by the brick school. In a 1901 election, a bond issue had passed to purchase the rest of the block on Wood Street for $2500. The new school was officially named the Joel Wood School, but was always referred to as the Wood Street School. Joel Wood was an early settler who owned land and laid out the town streets. Classes ended at the school in June of 1979, but the building was not razed until 1983. There was a great deal of discussion about what to do with the school and property. Eventually, the land was sold to a developer who erected Victorian-style houses that complemented this neighborhood of old homes.

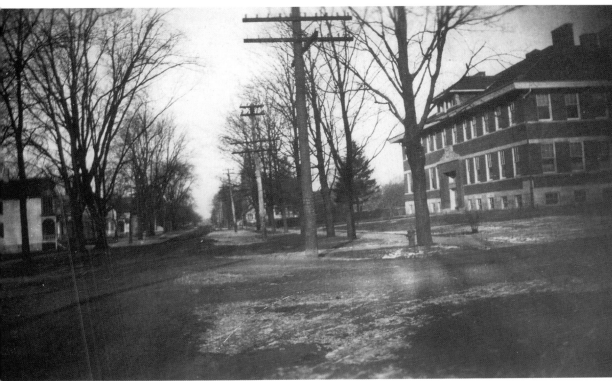

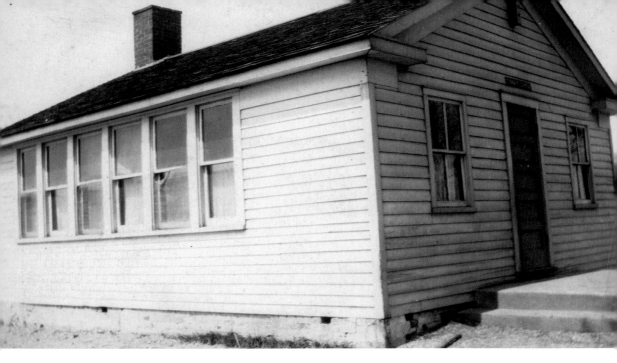

School District #16 has a history of two school buildings. The Wente School (*c.* 1880) shown in this picture was located on Quentin Road, just south of what is now the Fremd High School football field. In the late 1920s, enrollment dwindled so that the #16 district paid to send its few students to the District #15 town school. In 1930, when housing began to spring up in the area, the building became overcrowded with more than 25 students. By a unanimous vote of residents, they decided to build a new school, farther north and more central to the district. The Wente school building became the private home seen here. The new two-room Hillside School, built in 1931 on the east side of Quentin Road, was used by Consolidated School District #15 until 1964. Since no one wanted to buy the building, it was torn down and replaced with a District #15 administration building. That building is now the Palatine Township Senior Center.

The Cady, Boynton, and Sutherland families were among the first to settle in Palatine Township between 1836 and 1838. Ezekial Cady built a one-room log cabin for his family to live in while he was erecting a better house. That crude building on his farm near Dundee and Northwest Highway became the first school in Palatine Township in 1841 with Nancy Boynton (later Mrs. Mason Sutherland) as the teacher. It was moved south *c.* 1848 on Ela Road to the Bradwell farm and became the building for School District #17. This was probably replaced a few years later with the brick building pictured here at the site on the east side of Ela Road at the junction with Bradwell Road. Another brick Bradwell #17 school in the same spot was erected in the 1920s. The latter building was sold and converted into a home in 1948.

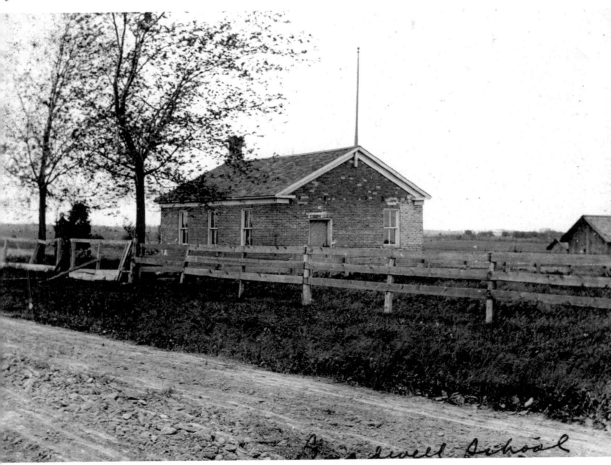

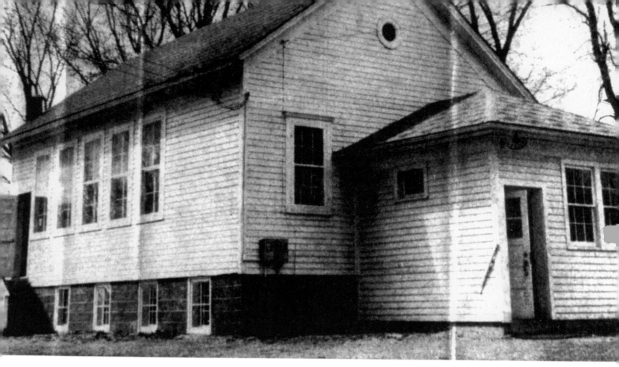

Highland Grove School (District #18) was located on the west side of Ela Road, south of Algonquin in a farm community which had long been known as Highland Grove. Some of our records indicate the school was also known as Plate School. This was the last rural school in the township to join Consolidated School District #15, probably in 1957, after a great deal of controversy among the residents because the consolidation would increase taxes. The building was sold at an auction and brought more than had been expected because two area farmers wanted the land. Currently, most of the farms in the area have disappeared, and this piece of land is now part of a Cook County Forest Preserve.

The one-room Plum Grove School (District #19) was located south of the village on Hicks Road. It drew students from the southeast area of the township. Our sources say that after the school consolidation, this building was moved to Bensenville and used as a home. When the Highway 53 expressway was constructed, the street became a frontage road. Bethel Lutheran Church held the first service in their newly constructed building on September 22, 1957 on this site. An education wing was built in 1959, and in 1967 the church structure was completed with the opening of a new sanctuary and office space.

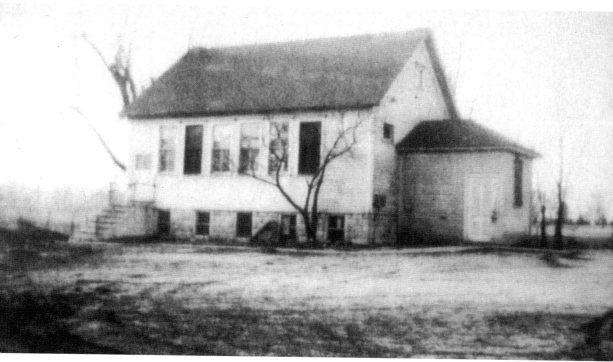

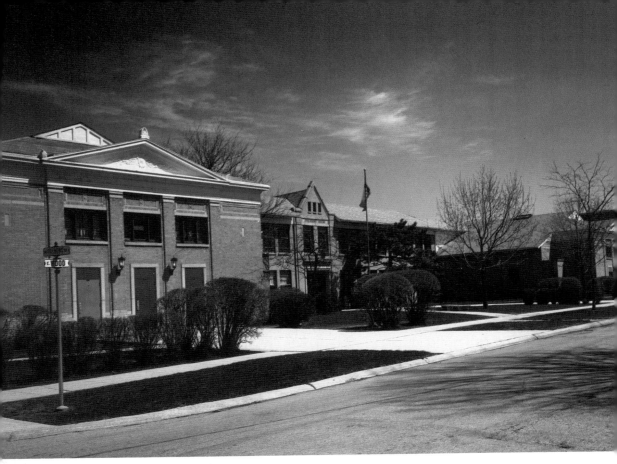

Palatine High School was established in 1876 by Superintendent Charles S. Cutting as a two-year program . By 1898 it had become a four-year course. Palatine Township High School District #211 was organized in 1914. Two referendums to build a separate high school failed before a successful vote led to the erection of this building on Wood Street at Fremont in 1928. It included an auditorium (Cutting Hall) and a gymnasium. By 1953 an academic addition and a new gymnasium wing had been built on the east. Another addition and remodeling of the building occurred in 1968. Although a second high school (Fremd) had been built on the south side of town, Palatine High became badly overcrowded. A new Palatine High School structure opened on Rohlwing Road in 1977. The Village of Palatine and the Palatine Park District purchased the old school to establish a municipal center. Both additions and Cutting Hall from the 1928 building were renovated. The rest of the original building was removed to create a parking lot.

When the people in this photo gathered for a PTA meeting in the 1930s, they formed the only PTA in Palatine School District #15. Their aim and activities were probably the same as those expressed in a 1955-56 program of the Parent-Teacher Association. "Let's understand the responsibilities of those entrusted with our children's future and accept our responsibility for better homes, schools, and community."

A letter from the Palatine PTA on December 12, 1934 thanked librarian Lottie Hart for her cooperation given to its Children's Reading Chairman in the group's Book Buying Service. In 2002, Palatine School District #15 consists of more than 20 elementary schools, junior high schools, and special learning centers. Each school has its own PTA group, united in the Northwest Suburban Council of Parent Teacher Associations. The women in this modern photo belong to the Lake Louise PTA of the year 2000-2001.

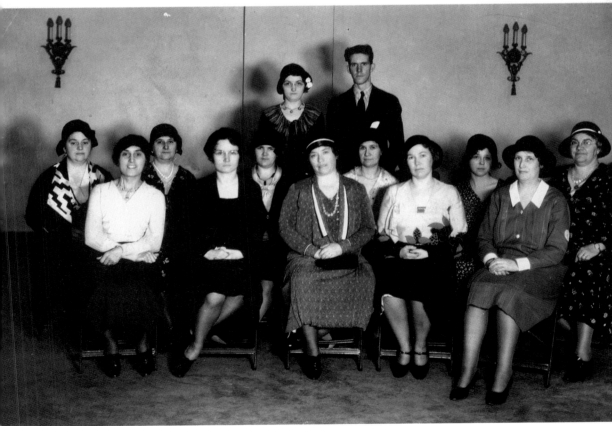

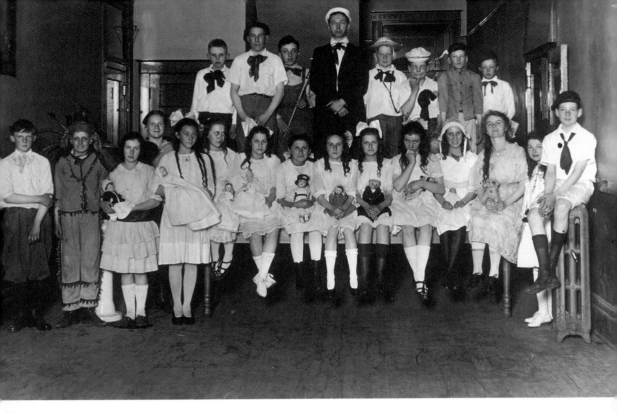

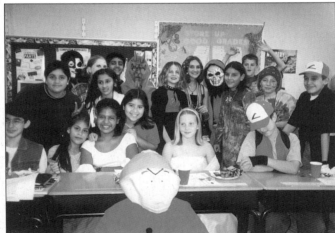

Parties in school have always been a part of the curriculum. This neatly arranged, neatly costumed group of students was celebrating Halloween in 1921 in the Joel Wood School. This is probably a high school class since all the students in this photograph have been identified. The tall person in the center of the back row is noted as "Prof. Kimball." The modern photo shows a group of students celebrating Halloween in a class at the Lake Louise elementary school, located at 500 North Jonathan Drive, during the school year 1999-2000. Because of society's present awareness and response to "political correctness," some traditional holiday parties, which have been held in our schools for many years, have been eliminated.

A four-day Great Indian Encampment was held beginning September 24, 1920 in Deer Grove Forest Preserve in Palatine Township. "Purpose: To bring the Indian residents of the state together in cooperative council for their advancement in tribal inter-relations, mutual benefit and to acquaint the white people with Indian customs, ethical standards and the true meaning of the Indian ritual." (*Cook County Herald, 17 September 1920*). A special program was held for the Boy Scouts and school children were urged to attend as well.

Chapter 5
POTPOURRI

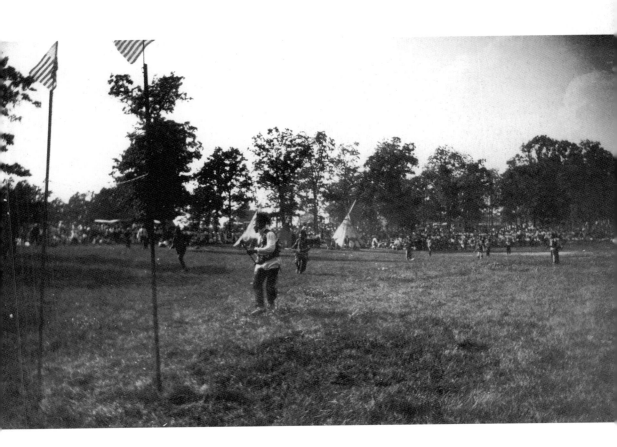

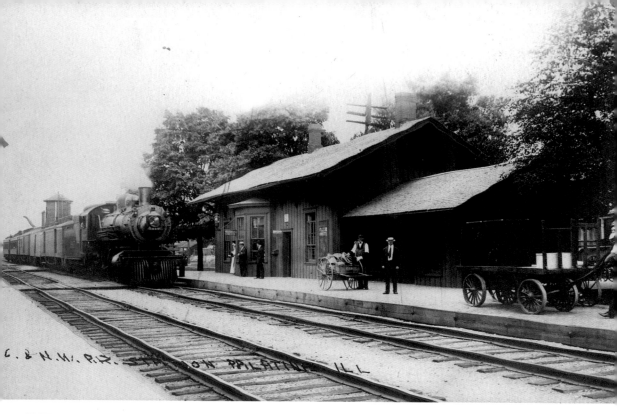

C. & N. W. R. STATION PALATINE ILL.

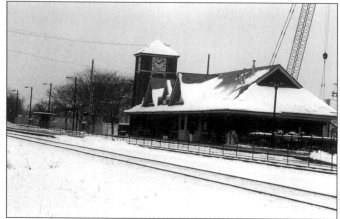

The railroad came to Palatine in 1855 and this depot was erected in 1866 on the north side of the tracks, east of Brockway. Passenger service on the Chicago and Northwestern Railroad began in 1873. The station had segregated waiting rooms, one for men and one for women. Oil lamps were in use in the building long after electricity came to Palatine. Aside from the duties of handling train traffic, the railroad agent had to fire the stove, keep the lamps burning, and sweep up. On June 22, 2001, Palatine dedicated its fourth depot, on the north side of the tracks, just east of Smith Street. The $3 million Metra station features arch-vaulted ceilings, chandeliers, a tiled floor, antique-style benches, an illuminated clock tower, and a three-tiered fountain. There are also public restrooms, an ATM, and a full-service Starbucks coffee shop with outdoor seating.

Two railroad stations served Palatine between the 1866 and 2001 buildings. In 1949, a modern depot was built just east of the 1866 station, north of the tracks at the Bothwell intersection, which was closed to traffic. The 83-year-old depot was torn down. The new building was warm and well-lit with recessed neon lights. Automatic crossing gates, which could also be controlled manually from the tower over the ticket office, were a welcome addition. The third station was moved away from downtown and erected west of Smith Street in 1971. The Palatine Transportation Center was the first of its kind in the Chicago suburban area. It combined a shopping center, ample parking facilities, and access to bus and taxi service. Unfortunately, the shopping center was unsuccessful and was not well-maintained.

The retail portion of the building was removed but the depot remained until the new Metra station opened, after which it was torn down. In 2002, the site is being developed as Gateway Center (office, retail, and parking).

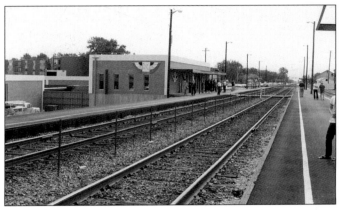

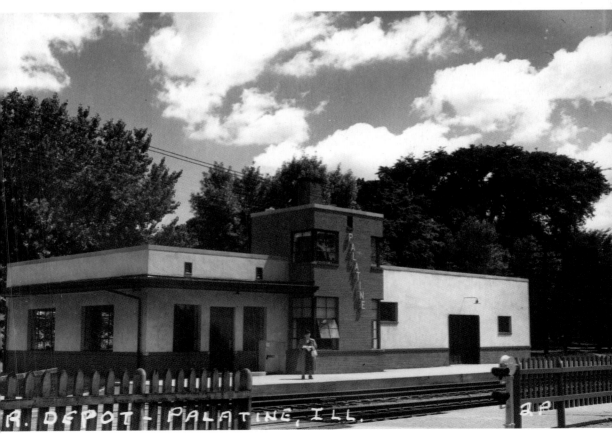

R. DEPOT - PALATINE, ILL.

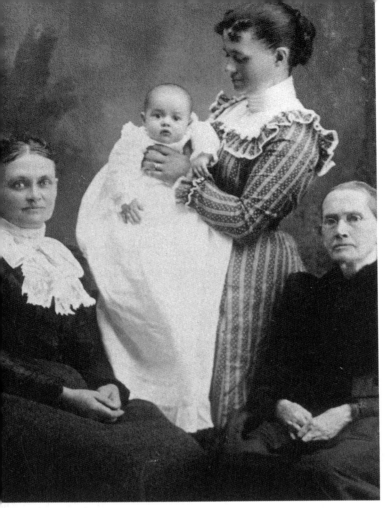

Four generations of Palatine residents are seen in this photo. Nancy Boynton (seated, on right) came with her family to farm in Deer Grove in 1838. She married Mason Sutherland, who had arrived in 1837. They settled on a farm on Dundee Road. After her husband's death during the Civil War, Nancy moved into Palatine and her family continued to live on income from the farm. Her daughter Emma (seated, on left) married Henry Matthei who operated a general store on the southeast corner of Bothwell and Railroad Avenue. The Matthei's daughter Annie (center) married William Brockway, who spent most of his career working for the railroad. The Brockway's daughter Mae (the baby) married William Howes, who worked for the railroad and the Cook County Forest Preserve. All the Sutherland women were active in community organizations. Georgiana Palmer, the daughter of Mae Howes, is joined in this modern picture by her daughter Virginia Lee Nemec in admiring a seventh generation Sutherland, Virginia's daughter Alexandra.

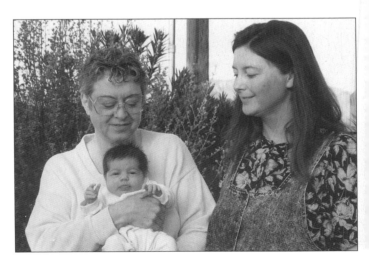

Helen Wienecke sits on the right front in this photo of the 1907 confirmation class of St. Paul United Church of Christ. Rev. J.C. Hoffmeister is also identified. St. Paul's was organized in 1871, and a year later the first wooden church was built near the northwest corner of Palatine Road and Oak Streets. In 1925, the original building was replaced by the current brick structure. There have been several additions through the years. The original charter of the church was written in German, which was also the language of the service. It was not until 1914 that the English language was introduced for part-time use in alternative services. The parsonage next door to the church was built in 1897 and is still in use. A second parsonage and a parking lot were constructed across Oak Street in the 1960s after the Hart property was purchased. In the picture of the 2001 St. Paul confirmation class, the woman standing third from the left is Rev. Michelle McNamara.

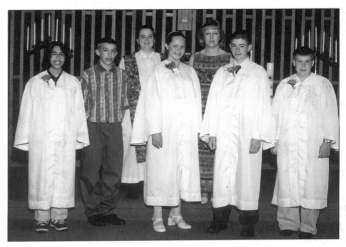

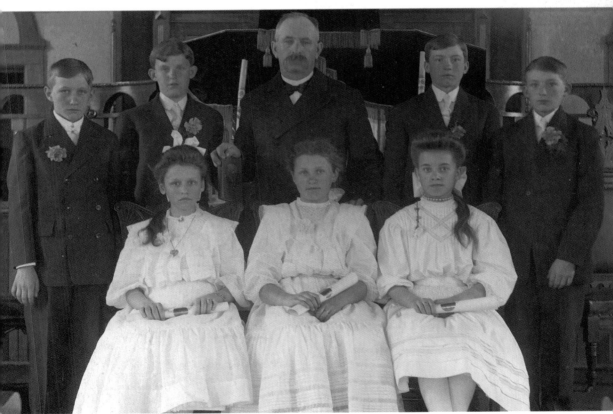

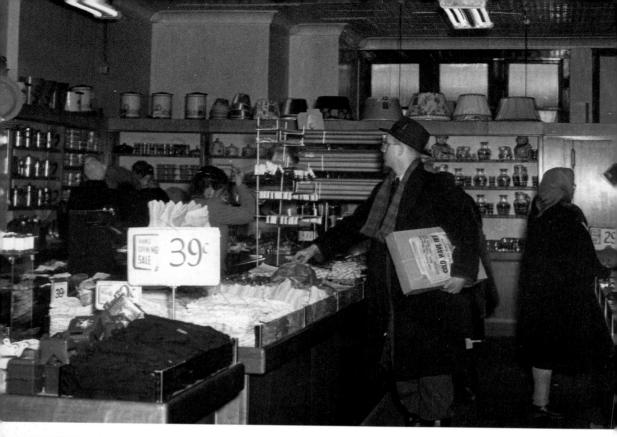

This photograph was taken inside John Wilson's Ben Franklin (variety store) on opening day January 29, 1949. The store was situated on the west side of Brockway, north of Slade Street, between Coleman's Pharmacy and the Left Bank (a boutique). It was in business there until the tragic events of February 23, 1973, when a raging fire destroyed the building. Three volunteer firemen died of smoke inhalation while battling the fire in the basement. John Wilson was owner of the Ben Franklin store; Warren Ahlgrim's family operated a funeral home on Northwest Highway; Richard Freeman's father, Howard, owned Zimmer Hardware and was also one of the volunteer firemen at the scene. The Ben Franklin Store reopened in the building at Wilson and Brockway, but did not remain in business there for long. The business block of the burned-out store was torn down and the site now serves as a parking lot. This modern photo, taken in the Target Store on Dundee Road, shows how we typically today.

The citizens of the Village of Palatine organized the Deluge Fire Company in 1877, when 45 men volunteered to serve. The first hand-pumper fire engine, pictured below, was purchased in 1887 and was moved either by horse or man power. The fire engine was sold by the village but eventually returned home and is now on display in the Carriage House/Deluge Fire Museum at 224 East Palatine Road. The first full-time professional firefighters were hired in 1971, and the first paramedics graduated in 1972. The last of the volunteers retired in 1984. In 2002, the Palatine Fire Department operates five firehouses. The Colfax Street station (at Hale) houses special equipment including a tower and squad car. The other four facilities are at 200 West Illinois, Palatine Road across from the Winston School Campus, Hicks Road south of Dundee, and Dundee Road west of Smith. Each facility houses an ambulance and a fire engine like the one pictured here. Of nearly 100 firefighters, most are also paramedics.

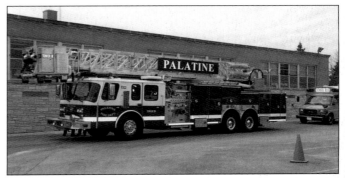

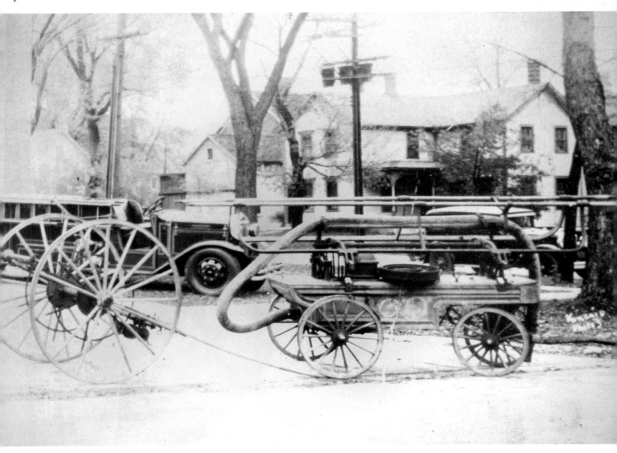

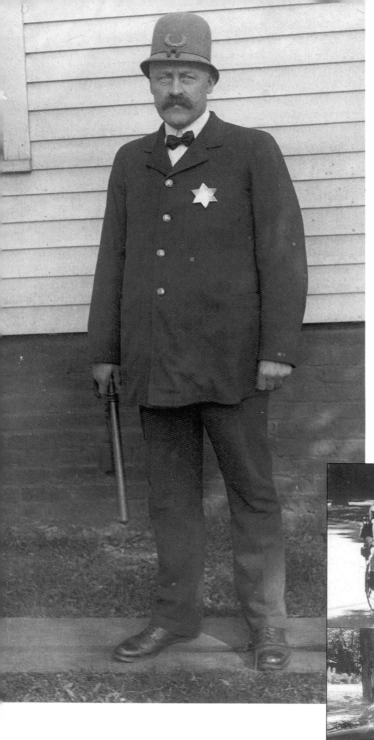

Henry Law was the first uniformed policeman hired by the Palatine trustees in 1913. Until then the task of protecting the village had been filled by part-time, salaried, or contracted employees. These men had served under various titles with duties including dog catching, cleaning the village hall, and lamp lighting. They patrolled on foot. The department became motorized in 1925 with the purchase of a motorcycle, and the first police car was added in 1938. The police department continued to operate as a part salaried, part special police, part volunteer organization. The first uniformed, salaried chief of police was appointed in February 1942 with two policemen under him. From a total of 14 members in 1959, the Palatine police force has grown to a staff of 150 employees by 2000. Its services are as extensive and varied as the modes of transport and personnel displayed in this collage. The officers are Patty Pierce on the bicycle, Dan Bonneville on the motorcycle, and Pat Johnson with "Crow," the canine member of the force.

Walter and Helen Rennack are out for a ride in their little "convertible." This photo was taken around 1919, as that was the year they were married. Helen Rennack, the daughter of Conrad and Sophie Wienecke, was in the St. Paul confirmation picture. Walter Rennack was a contractor. He built many houses in town and an addition to St. Paul's Church, and he oversaw the 1958 renovation of the library at Wood and Brockway Streets. The boardroom at the 1975 library on Benton at Northwest Highway was named for him. The two SUVs in the other photo are typical of the current suburban lifestyle. The woman standing is Susan Lutostanski, a graduate of Palatine High School and daughter of Alice Rosenberg, author of this book. The boys hanging out of the car are her 16-year-old twins. A third family car sits in the driveway when her college-aged son is home from school.

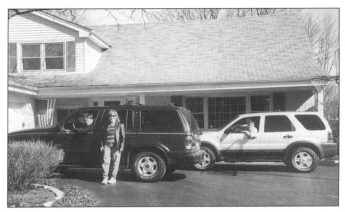

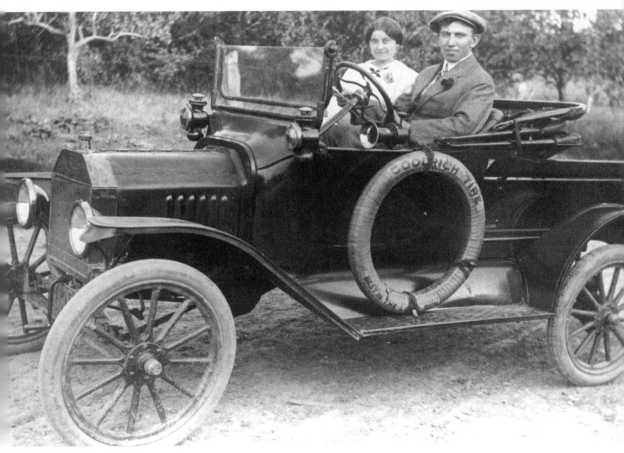

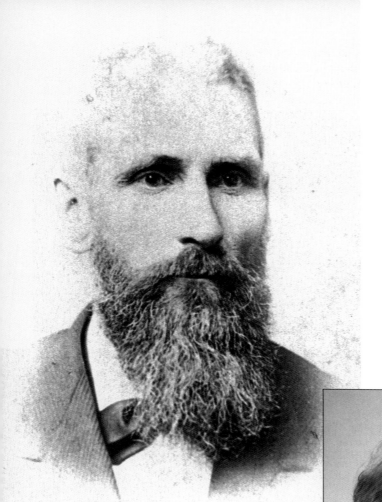

local theater, Cutting Hall, bears his name. It took 133 years and 33 village board presidents before a woman, Rita Mullins, was elected mayor in 1989. She currently serves in that office, to which she has been reelected three times. Her career Marine father settled the family in Palatine in 1958, after having lived in different parts of the country. Rita graduated from Palatine High School in 1963. She has worked in the real estate, insurance, and banking fields, and for ten years operated an antique and gift store in downtown Palatine. She served for eight years as Village Clerk before being elected mayor. She serves in many local, regional, state, and national organizations, and has done extensive world traveling to speak about governmental issues affecting municipalities.

Myron Lytle was the first mayor of Palatine when the village was incorporated in 1866. He had come to town as a young man and married Ann Bradwell, daughter of Thomas Bradwell, a prosperous farmer. Myron operated a grocery store with Charles Pierce just after the town of Palatine was surveyed. Later he was a lumber dealer and a partner in a grain elevator. At the time of his death he ran a poultry farm. The Lytles had one child, Annie, who married Charles S. Cutting. Cutting began the high school department of Palatine School, and the

The Palatine Military Band was organized in the 1870s by J.H. Schierding, a mayor of the village. It was considered one of the best bands in Cook County. It won prizes and laurels in Chicago, Elgin, and other nearby communities. The band performed concerts and played in parades. This photo was taken around 1900. The nature and the name of the band changed over the years. In 1958, the municipal band was outfitted with new caps and ties and re-titled the "Palatine Village Band." For the first time, women musicians were invited to join. It is now known as the Palatine Concert Band. Performances are held during the summer in the Community Park Amphitheater, which was erected in the 1980s. During the summer, a number of excellent musicians from several high schools and colleges augment the ranks of the band.

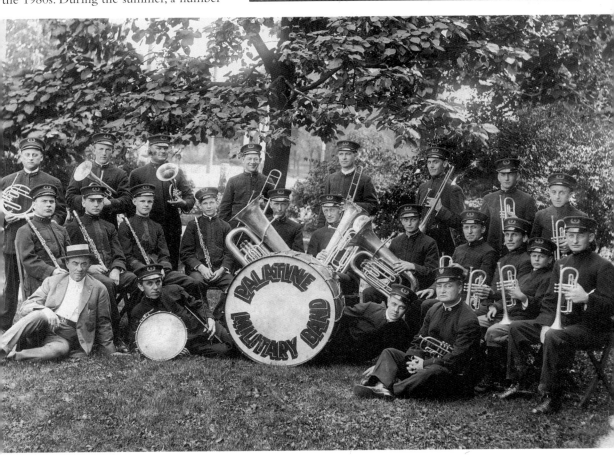

In this July 4, 1917 photo, the parade float was passing the bandstand at the northwest corner of Brockway and Slade Streets. Florence Parkhurst remembered celebrating Independence Day in the early 20th century with her large Palatine family and other relatives who arrived by train. In addition to the parade, there were always ballgames or races at Dean's Park to watch, a picnic at Deer Grove, a band concert, and a fireworks display. Palatine still celebrates the Fourth in a big way, courtesy of the Palatine Jaycees. The Festival includes a parade, fireworks, carnival rides, and food booths. The Palatine Jaycees were organized by 20 young men 1957. The Jaycee Women's Auxiliary joined the organization under one banner in 1985. The float shown in this 1999 parade was built by the Palatine Historical Society, an annual participant in the parade. The theme in 1999 was "Amendments to the Constitution." The Society, which is composed mostly of women, naturally chose the 19th Amendment, which gave women the right to vote.

The carriage entrance in this early 1900s photo is in Deer Grove Park on the east side of Quentin Road, north of Dundee. This was a private park of 70 acres built by Dr. John Wilson, a Palatine veterinarian. It had a dance pavilion, a track, ball grounds, a refreshment parlor, and a dining hall. The PLZ&W Railroad (and earlier a horse-drawn bus) brought Chicago people directly to the park from the railroad depot in Palatine. The Board of Forest Preserve Commissioners bought this land as well as other parcels. They dedicated the land as "Deer Grove" on June 16, 1917. It was the first park in the Cook County Forest Preserve system. The buildings from the Wilson property formed the nucleus of what was soon to become Camp Reinberg, named after the first president of the Board, Peter Reinberg. The camp facilities have been expanded and are operated both by the county and by not-for-profit organizations.

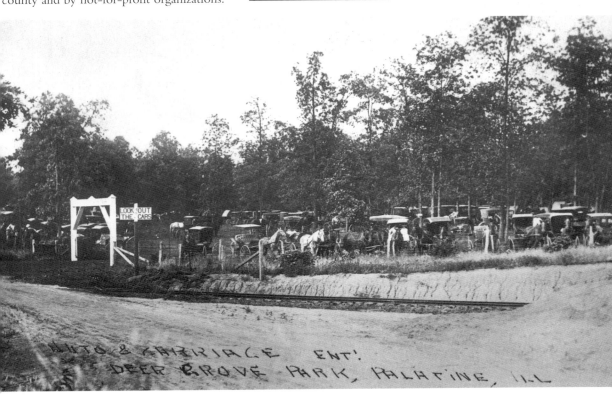

which is now the site of Heng Wing Restaurant. The 1910 census lists him as working at the family flour mill. The wedding was held in the Ost home, where supper was served to 100 people. Many of the couple's friends, who had not been invited to the wedding, dropped by in the evening and an impromptu reception was held on the lawn. The newlyweds lived on the Ost farm near Long Grove and later moved to Barrington. The modern wedding couple pictured here are Christine Pedersen and Scott Ocheltree. Christine is the daughter of Alfred and Marilyn Pedersen. Marilyn is the coordinator of the Clayson House Museum of the Palatine Historical Society. The Pedersen wedding took place June 23, 2001 at St. Thomas of Villanova Church on Anderson at Williams. About 200 guests attended the reception that was held at the Hyatt Woodfield Hotel inside an air-conditioned tent.

Elsa Fredricke Wickersheim and Edward W. Ost were married at three o'clock on September 2, 1914. Edward Ost was the son of Charles Ost who operated a flax mill, flour mill, and a lumber planing mill in the firm of Batterman, Abelman & Ost. Edward had grown up in the Ost home at the corner of Greeley and Palatine Road,